T0386553

RICCIO'S
OIL LAMP

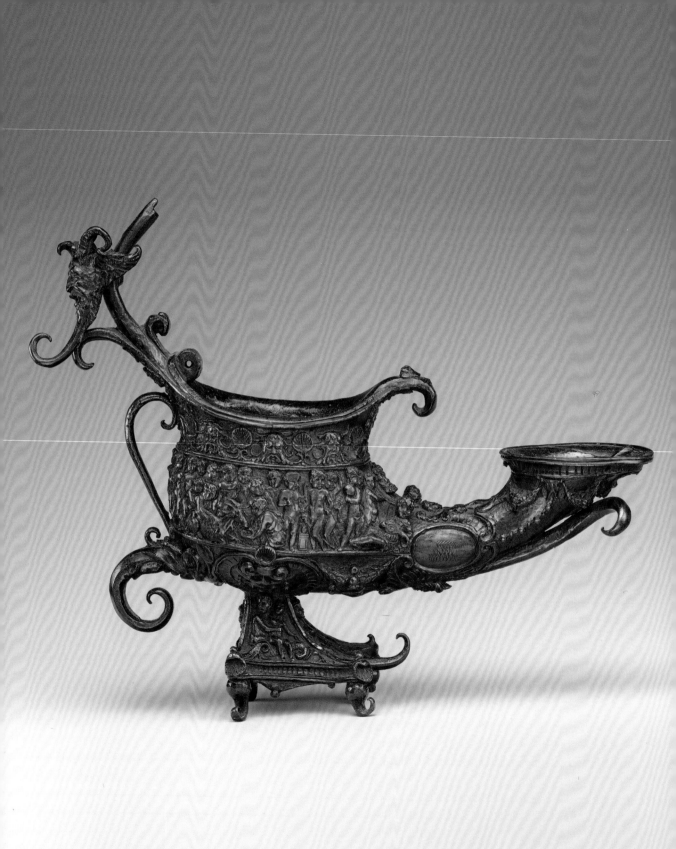

RICCIO'S OIL LAMP

James Fenton

Ian Wardropper

The Frick Collection, New York
in association with D Giles Limited

g

FRICK DIPTYCH SERIES

Designed to foster critical engagement and interest specialist and non-specialist alike, each book in this series illuminates a single work in the Frick's rich collection with an essay by a Frick curator paired with a contribution from a contemporary artist or writer.

Copyright © 2023 The Frick Collection

First published in 2023 by The Frick Collection
1 East 70th Street
New York, NY 10021
www.frick.org

Michaelyn Mitchell, Editor in Chief
Christopher Snow Hopkins, Associate Editor

In association with GILES
An imprint of D Giles Limited
66 High Street
Lewes, BN7 1XG, UK
gilesltd.com

Copyedited and proofread by Sarah Kane
Designed by Caroline and Roger Hillier,
The Old Chapel Graphic Design

Produced by GILES

Printed and bound in China

A CIP catalogue record for this book is available from the Library of Congress.

ISBN 978-1-913875-31-2

Cover and pages 8 and 62: details from Andrea Briosco, known as Riccio, *Oil Lamp* (frontispiece)
Frontispiece: Andrea Briosco, known as Riccio, *Oil Lamp*, ca. 1505–15. Bronze, 6⅝ × 8⅜ × 2⅜ in. (16.8 × 21.3 × 6.1 cm). The Frick Collection, New York
Page 10: Kerosene lamp in the author's cabin, Deer Isle, Maine

CONTENTS

ACKNOWLEDGMENTS

Fashioned by the Renaissance sculptor Riccio, The Frick Collection's bronze oil lamp is both a unique and sophisticated work of art and a fascinating talisman of the culture that produced it. Benefiting from the research of many scholars who have studied this area of art history, this book situates the oil lamp within the intellectual milieu of the city where it was made and owned, Padua, and the artistic achievement of its maker, Riccio.

It is fortunate that James Fenton, a poet, as well as a critic and collector of sculpture, shared my enthusiasm for the subject. The books in the Frick Diptych series encourage submissions in various forms from artists and writers; his lines evoke the making and mystery of this object in ways that art historical texts never could.

As a sculpture specialist, I am especially mindful of my debt to scholars who precede me. When the Frick's *Illustrated Catalogue* on Italian sculpture was published in 1970, it was researched and written by two of the top experts in the world, John Pope-Hennessy assisted by Anthony F. Radcliffe. This ensured that the catalogue entries on Riccio were informed by the latest knowledge in the field. Both of these scholar-curators went on to write some of the most influential books on European sculpture, and Tony Radcliffe, a generous mentor to all, produced a magisterial article on Riccio's oil lamps that remains the touchstone for any analysis of these works.

I was John Pope-Hennessy's research assistant when he moved to New York to teach at the Institute of Fine Arts and become the chairman of the European Paintings Department at the Metropolitan Museum of Art. My own interests in Renaissance bronzes, however, were piqued by courses taught by another curator at the Met, Olga Raggio, and it was in one of her seminars in the 1970s that I first had the opportunity to study the Frick's oil lamp. Raggio's Department of European Sculpture and Decorative Arts was the locus of studies on bronzes by curator James David Draper and by conservator Richard Stone, a pioneer in technical studies of the medium. In due course, I became chairman of the department, continuing to work with such inspiring colleagues, and had the rare opportunity to acquire for that museum another oil lamp by Riccio, which is described in these pages.

By coincidence, that acquisition was made just as the major exhibition *Andrea Riccio, Renaissance Master of Bronze* was on view at the Frick in 2008–9, though

it arrived too late to feature in the show. One in a series of exhibitions on bronzes at the Frick, this was organized by Denise Allen and Peta Motture. Its scholarly catalogue continues to be a resource on Riccio, and its contributing authors—including Davide Banzato, Rebekah A. Carson, C. D. Dickerson III, Volker Krahn, Claudia Kryza-Gersch, Philippe Malgouyres, Alexander Nagel, Franca Pellegrini, Eike D. Schmidt, Jeremy Warren, and Dimitrios Zikos—continue to illuminate the field of Renaissance sculpture. I am also grateful for the publications on the use and function of artworks in the Renaissance by Dora Thornton and for assistance and useful suggestions from David Ekserdjian, Sean Hemingway, Sarah Lawrence, and Stephen Scher.

At the Frick, I am indebted to Deputy Director and Peter Jay Sharp Chief Curator Xavier F. Salomon and Assistant Curator of Sculpture Giulio Dalvit, who were astute readers of my text. Giulio added some invaluable research on the early owners of the oil lamp. Chief Conservator Joseph Godla; Patrick King, Head of Art Preparation and Installation; Head Photographer Joseph Coscia Jr.; Frick Art Reference Library Storage and Retrieval Lead Eugénie Fortier; and Curatorial Assistant Gemma McElroy all helped me in various ways. Director's Office Assistants Sarah Thein and Blanca del Castillo tracked down books, secured reproduction rights, and performed other essential tasks. As always, Editor in Chief Michaelyn Mitchell and Associate Editor Christopher Snow Hopkins skillfully groomed the text of this latest volume—the eleventh—in the Frick's Diptych series.

I accomplish little in life without the support of my wife Sarah McNear. That we were both writing books during the pandemic made the parsing of sentences a shared endeavor. If this work was mainly illuminated by the electric lights in our home offices, it was done in the spirit of study by oil lamp, which has guided scholarship for centuries.

Ian Wardropper
Anna-Maria and Stephen Kellen Director, The Frick Collection

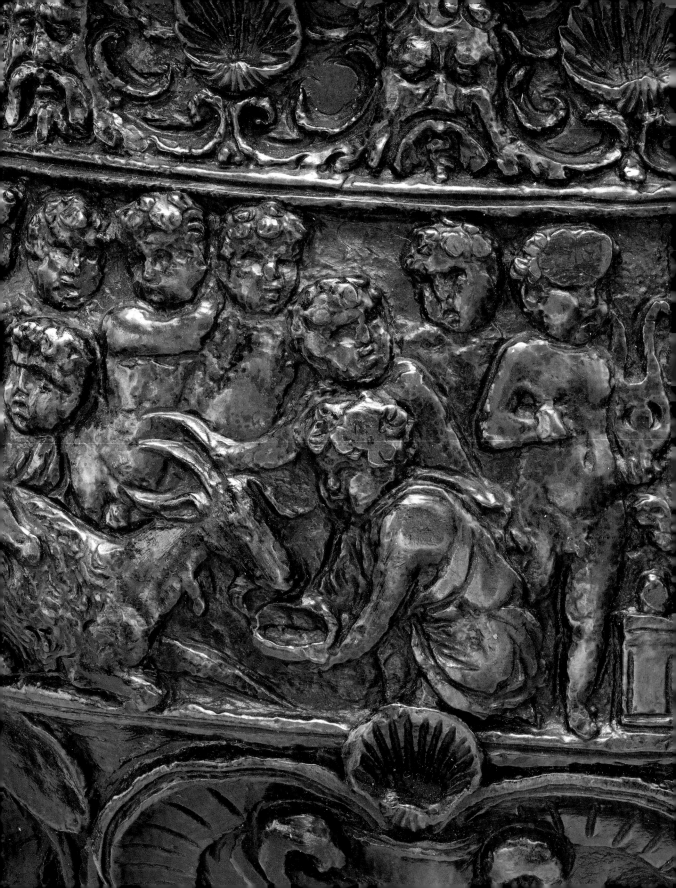

THE WORLD OF ANDREA RICCIO

James Fenton

A voice comes calling out of Arcady.
Give me the helmet with the missing knop,
The casting flaw, the imperfection.
Give me the satyrs and the satyresses,
The fifty nereids, those moon-princesses,
The daughters of the old man of the sea
And these medusas with their hissing tresses,
Hissing as the hot wax hisses in the sprue.
They do what the ichthyocentaurs do.
These agitated hippocamps
Reflect the dimpled surface of the lamps
As night falls to the tapping of the peen.
One tends the hot ore. One controls the fire.
Seven the planets, seven the strings of the lyre,
Seven the last words of the dying god –
The ram, the lamb, the goat, the ivy-crowned,
The vine-leaf- and the laurel-wreath-bedecked.
The listening mouth falls open to the sound
As now the naked spiritelli pass
Bound for the sacrifice.
They will have blood and yet be innocent.

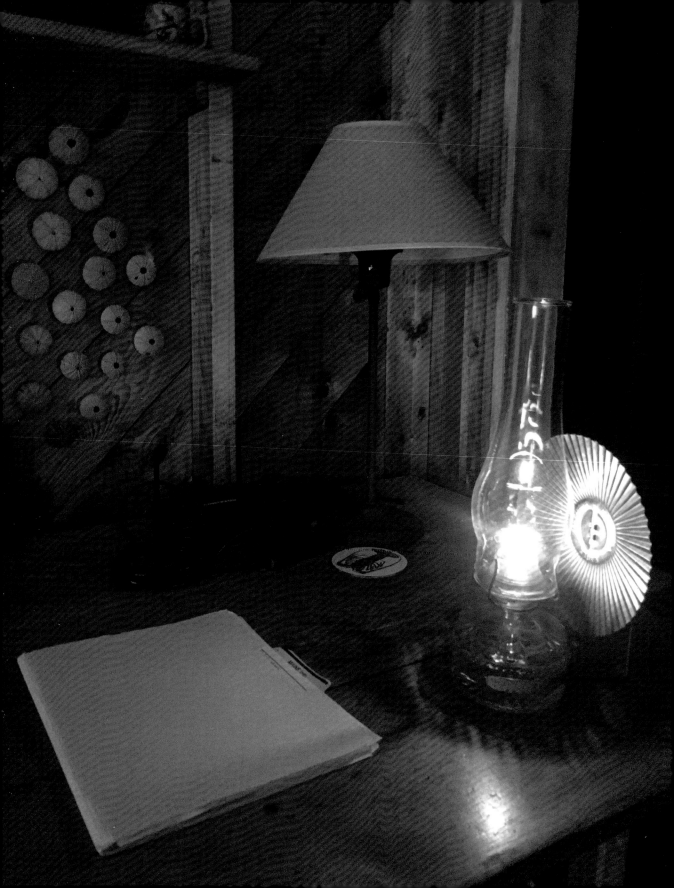

RICCIO'S OIL LAMP

Ian Wardropper

Preamble

One October when my wife and I were staying in our Maine cabin, a storm ripped through the island, and toppled trees downed power lines and crushed our car. Isolated and without electricity, we turned to what resources were at hand: for heat, I split logs to feed the wood-burning stove, and for light, I lit the kerosene lamp.

At night, the lamp was a reliable tool for reading, its single source of illumination comforting in the dark. The white-hot wick sharpened my focus on a book, while its limited radius blurred any visual distractions out of its range. Unlike the predictable clarity of a light bulb, the flame's slight flicker conjured up an air of mystery and encouraged reverie, reminding me of the importance of lamps in earlier times. Instead of simply flipping a switch, I had to tend to fuel levels and regulate the length of the wick. Mine was a strictly utilitarian affair: a pressed-glass kerosene container, a tall glass top to protect the wick from wind, a circular tin reflector, and a metal rim and handle to connect these parts and move it about. The lamp's lack of design flair underscores the ubiquity of these necessary household items, produced by the score. Yet its value to me in a time of need and my close connection to it during use made me understand why artists or craftsmen in earlier eras might lavish attention on such seemingly pedestrian objects.

This experience renewed my interest in a unique and fascinating work of art in the Frick's collection. While my kerosene lamp recalled ancestors who depended on such implements a century ago, Riccio's oil lamp (frontispiece) was designed to remind its Renaissance owners of their ancient Roman

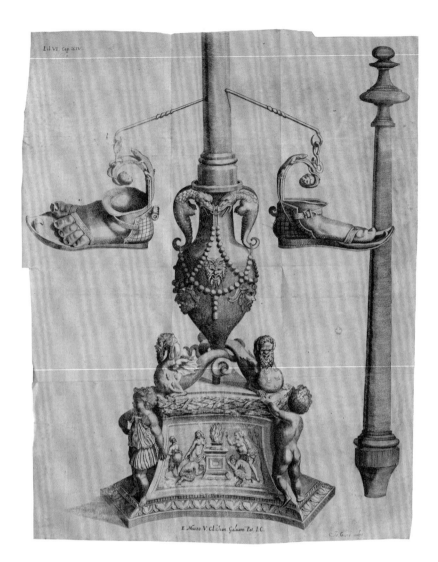

Fig. 1
Bronze Lamp Stand
Engraving in Licetus 1652,
pages 667–68

Fig. 2
Other side of Riccio's *Oil Lamp*

forebears more than a millennium earlier. To modern eyes—and even to those at the time it was fashioned some five hundred years ago—it is a curiosity. Yet its purpose would have been immediately evident, as such oil lamps—often based on ancient prototypes—were still in use alongside candlesticks. Fuel poured into the central cavity flows to the spout or wick pan, where the flame is lit. A socle elevates the lamp, so that its light can spread over manuscripts or books on a desk. The curling elements at the back allow it to be carried by hand, while the now-broken rod at the top was intended for suspending it from the ceiling or from a stand to cast its light even further (fig. 1). That

Fig. 3
Underside of Riccio's *Oil Lamp*
with socle removed

this topmost curl snapped off suggests that it was hung but that over time its tensile strength proved too fragile for the purpose.

What makes this Renaissance object remarkable is its abundant, even ornate, decoration. Its primary element takes the shape of a boot. On its pedestal, it stands about six and five-eighths inches tall, and it is some nine inches in length—that is to say, about the size of an average foot. Relief decoration covers its bronze surface. One inch high, the principal scene circling the lamp represents a band of children. On one side toward the center, a ram has been led to be sacrificed, and a child kneels, extending a bowl ready to catch its blood. On the other side, the ram's severed head rests on the ground, while a satyr is carried piggyback toward it (fig. 2). The attendant children play a variety of musical instruments. Above this scene, but below the cavity's rim, bearded male heads alternate with scallop shells, joined by foliate strings. In an echoing motif, garland swags link ox skulls (*bucrania*) around the spout. Variations of these motifs cover the bottom of the vessel (fig. 3): *bucrania* are centered on flanking medallions, and in the center is a sphinx whose arms are wings, legs tendrils, and torso an ox skull. Such attention to the embellishment of the lamp's underside indicates that the artist intended it to be admired from all angles and that, if the lamp were hung, this portion would be more visible. The quadrangular socle displays coupled sea creatures—tritons and nereids—on its long sides and single busts on the short ones.

This whole mass of bronze is offset by spindly curls, which emerge from the front and back of the upper rim, beneath the front and rear of the boot,

up along its back, and from the front of the socle. A grotesque mask leers from the rear of the uppermost curl of metal. As noted, some of these elements allowed its user to handle or hang the oil lamp. The foliate decoration across the bronze's surface suggests an organic quality, as it seems to sprout like tendrils from a fecund mass. The shoe form also connotes laces that would thread through leather to bind ancient boots. Formally, their rhythmic curves enliven the lamp's silhouette, while their thinness lightens the edge of the dense object they surround.

Traveling over the lamp's highly worked surface, one's eye notices what is missing from its top. In addition to the broken handle above, a hinge reveals the absence of a lid, which would have covered the oil within and swung open for replenishing it. At the front of the lid, one can make out a tiny foot. It is roughly proportional to the children in the band beneath, so a child must have once stood there.

This is a hybrid object. It could be classified among the decorative arts since it had a practical function. Yet it was made by one of the greatest sculptors of the Renaissance, Andrea Briosco, known as Riccio (1470–1532), and is so encrusted with raised forms that one might think of it as a three-dimensional relief. As we will see, all its motifs are culled from ancient sources—small bronzes, sarcophagi, statues—but they have been synthesized into a quintessentially Renaissance idiom. Thus, it is surprising to learn that little more than a century after its casting, it would be mistaken for an ancient work. What did these reliefs and decorations mean to contemporary viewers? Why is it shaped like a boot? Who would have owned such an object, and what was its significance to its first owners? Why was the fact that it was modern and not ancient so quickly forgotten?

Licetus's Engraving

Fortunately, answers to some of these questions are found in an engraving published in Udine in 1652 by Fortunius Licetus in his *De lucernis antiquorum reconditis* (fig. 4).[1] The engraving and its accompanying text provide a wealth of information that is unusual for a five-hundred-year-old object. The depiction clarifies that about a hundred and thirty years after it was made, the lamp handle had already broken off, the lid was missing, and the figure standing at front—except for his foot—had disappeared. It adds another piece of information that we did not know: there was once a lyre-playing child seated on the curl above

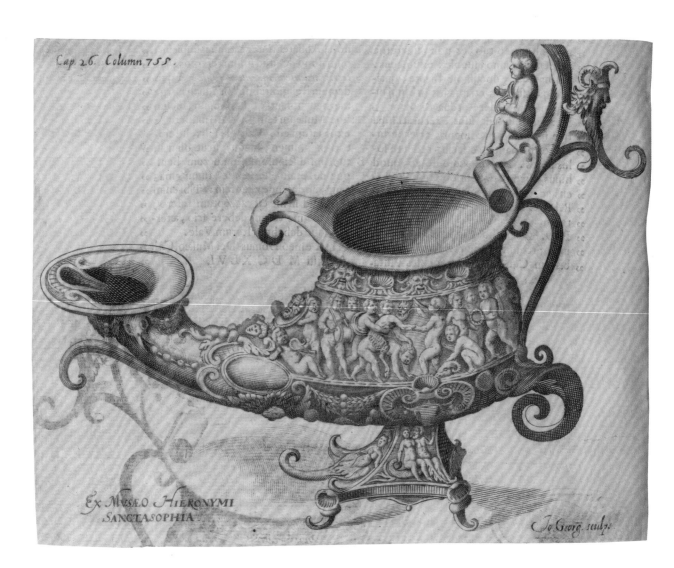

Jo. Georg. sculp.

the hinge. A putto in the Victoria and Albert Museum gives an idea of what this small, independent statuette might have looked like, though it is winged and plays a fiddle (fig. 5).[2] At two and seven-eighths inches high, it is taller than the figures on the oil lamp reliefs, though the engraving suggests a larger scale for the statuettes than the reliefs. Since this missing boy plays an instrument, as do some of those below, perhaps the standing figure at the front was also a musician.

Licetus includes this bronze in a treatise on ancient lamps, and his commentary mistakenly refers to it as an antiquity. He also lists three owners, at least one of whom might have known that this was a modern work and even have commissioned it from Riccio. It may seem odd that such a fact was so soon forgotten, but the misidentification of Renaissance bronzes as ancient happened frequently. Jeremy Warren has studied the case of an inventory published in 1632 of nearly forty bronzes in Roberto Canonici's collection.[3] The owner believed that nearly all of his works were ancient Roman or Etruscan in origin, whereas Warren demonstrates that almost all of them were made in northern Italy in the late fifteenth or sixteenth century. Although there are examples of deliberate forgeries in this period, it seems more likely that these works were conceived in homage to the ancient works that inspired them. Like Canonici, who specifically sought out ancient works rather than Renaissance bronzes *all'antica*, some buyers thought that they were ancient and may have been encouraged to take this view by dealers eager to make a sale. Confusion over distinguishing ancient from Renaissance works persisted into the nineteenth and twentieth centuries, until scholars such as Wilhelm von Bode began to systematically differentiate old from new, that is to say, bronzes made in the early centuries of the Christian era from those made about fifteen hundred years later.[4]

The engraving in Licetus's publication identifies its owner in 1652 as Girolamo Santasofia in Padua, and the text also mentions two previous owners: Pietro Campesio (Latinized by Licetus as Petrus Campesius), followed

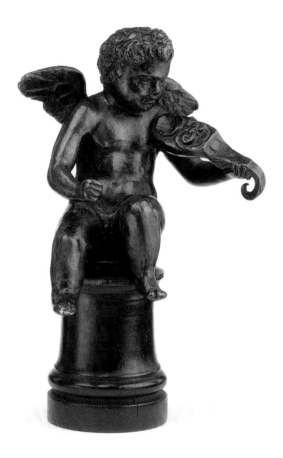

Fig. 4
Riccio's Oil Lamp
Engraving in Licetus 1652, pages 755–76

Fig. 5
Andrea Briosco, known as Riccio
Winged Putto, ca. 1500–1515
Bronze
H. 2⅞ in. (7.3 cm)
Victoria and Albert Museum, London

by Giacinto Fagnani (Hyacinthus Fagnanus), both of Padua. Campesio was a medical doctor at the University of Padua, one of the greatest institutions of higher learning in Europe. He is said to be an "R.P.," that is *reverendus pater*, or reverend father, which means that he was a canon regular of the Lateran and a priest. As such, he would have belonged to the abbey of San Giovanni di Verdara in Padua. One of the most cultivated monasteries in Italy, it housed a vast collection of books and art objects amassed by its canons, culminating with the famous collection of Marco Mantova Benavides (acquired after 1711).[5] The oil lamp may have been part of one of these collections.

Giacinto Fagnani is called "P.D.," probably meaning that he belonged to the Dominican order. If that is the case, he would have lived in the church and convent of Sant'Agostino, in Padua, now destroyed. A letter by Santasofia quoted in Licetus's treatise refers to Fagnani as a good friend, implying that he lived in the seventeenth century; one would think that the Riccio oil lamp passed directly from Fagnani to Santasofia. The Santasofias were a long-established family of scholars in medicine, active at the university since the fourteenth century.[6] Girolamo, who died in 1685, was engaged in contemporary debates over understanding physiological phenomena in mechanical terms rather than through the prevalent context of applying Aristotelian natural philosophy.[7]

This chain of ownership was through like-minded collectors who shared professional or religious backgrounds. Since Riccio lived and worked in Padua, it is likely that the oil lamp had not moved far from the sculptor's workshop in the intervening years. At this center of classical learning and of the study of ancient civilizations, Paduan scholars most likely advised Riccio on his subjects and their interpretation and were some of his principal clients.

We know nothing more about the subsequent history of the lamp's ownership until it was sold to J. P. Morgan in London in 1910 and then purchased by Henry Clay Frick from Morgan's estate through the Duveen Brothers firm in 1916.[8] Frick handpicked most of the collection's superb group of Renaissance bronzes from Morgan's holdings after the banker died in 1913.[9] Interestingly, the Riccio lamp appears in a French publication by Charles César Baudelot de Dairval (1648–1722) in 1686 (fig. 6), but, rather than indicating that the object itself had transferred to somewhere north of the Alps, this seems to testify to the influence of Licetus. As the title suggests, Baudelot de Dairval's two-volume treatise *De l'utilité des voyages, et de l'avantage que la recherche des antiquitez procure aux sçavans* encourages the study of antiquity through travel.[10]

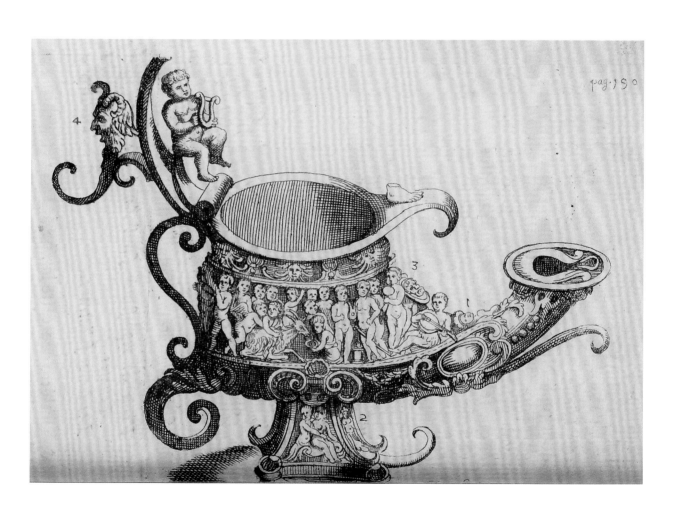

Baudelot de Dairval was a Parisian lawyer and collector of antiquities, and many of the reproductions are of objects that were in his personal collection of books, prints, manuscripts, and marble and bronze statues. His writing clarifies that he did not own the lamp but rather that the engraver Franz Erlinger faithfully copied the one in Licetus's book, adding the numbers 1–4 in reference to the text. The lamp is included in a chapter on the ancient Roman household gods known as Lares. Baudelot de Dairval's theory is that the oil lamp scene represents not a Bacchic rite of the sacrifice of a ram but rather a festival celebrating the abolition of the sacrifice of children. This misinterpretation of a passage from the ancient author Pausanias is symptomatic of the frequent debates then and now on the meaning of ancient scenes.

Oil Lamps and Inkwells in Renaissance Households

How did the owners of the Frick oil lamp use and display it? Paintings and drawings give a sense of the furnishings of scholars' studies in the sixteenth century; art historians like Dora Thornton have reviewed the evidence extensively.[11] Because of its wealth of detail, Vittorio Carpaccio's painting *The Vision of St. Augustine* (fig. 7) in the enchanting Scuola di San Giorgio degli Schiavoni in Venice often serves to chart the objects and implements a scholar placed on or within reach of his desk. Though the theologian and bishop lived in the fourth and fifth centuries, the Venetian painter depicts the saint in a study based on examples he might have known in his own time. Pausing to look out the window while writing at a trestle table, Augustine sits in a spacious room lined with objects and books; on the far wall is an altar within a niche. As it is daytime, none of the tallows in the candlesticks are lit, and no oil lamps are visible. Still, the apparatus of a scholar's study—inkstand, bell, astrolabe, a rack for manuscripts, a turnstile stand for books in the reading room beyond—is shown in considerable detail.

In view of the misidentification of the Riccio oil lamp as ancient, and the mixture of ancient and modern bronzes in collections of the period, the row of statuettes on the shelf along the sidewall is revealing. The statuette of Venus, for example, could have been an ancient work, a modern variation of an older type, or even an outright forgery. The diplomat and collector Cardinal Antoine Perrenot de Granvelle (1517–1586), for example, acquired a Venus that was rather like this one but which later proved to be a forgery.[12] While the female figure could have been old or new, the bronze horse near her is modeled after

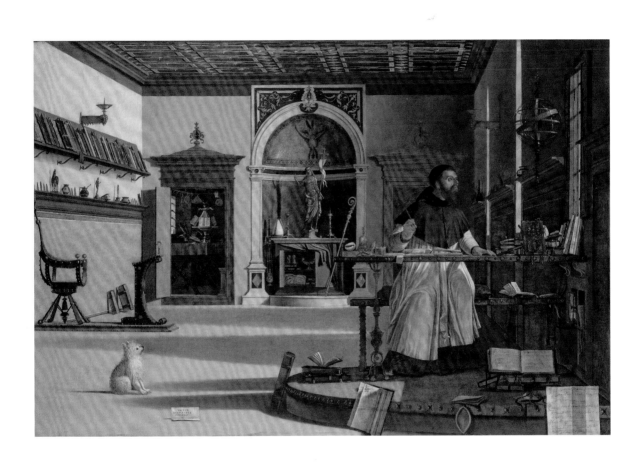

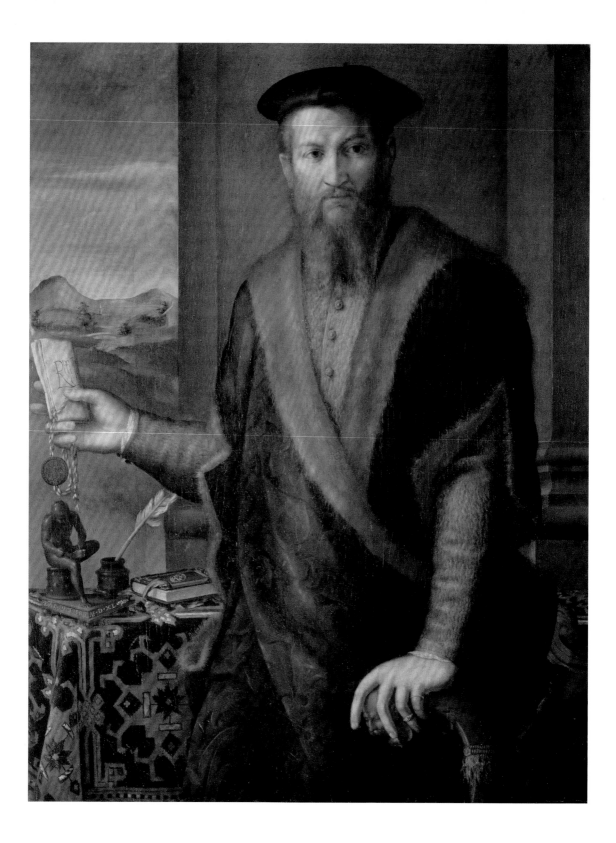

one of the four ancient horses on the facade of St. Mark's in Venice, so this is a modern reproduction in miniature. In both cases, these recalled the ancient world, whether an actual antiquity, a work mistakenly believed to be ancient, or a modern copy. Scholars versed in Greek and Roman literature wished to surround themselves with objects that reminded them of their studies and served as conversation pieces to spark discussions with their fellows.[13]

As the desks and shelves of Renaissance scholars filled with ancient and contemporary statuettes, as well as writing accessories, objects combining such functions inevitably followed. In Pierfranceso Foschi's *Cardinal Antonio Pucci* (fig. 8), the cleric holds a sealed document over a stand that supports an inkwell alongside a statue of the famous ancient Spinario.[14] Its triangular base carries the gilt letters and numerals of the painting's date: December 1, 1540. Noted since at least the twelfth century, the life-sized Greco-Roman bronze of a boy pulling a thorn from his foot, now in the Capitoline Museum in Rome, was one of the first ancient sculptures to be extensively copied.[15] Its fame was such that Severo da Ravenna, a northern Italian rival of Riccio's, mounted a miniature copy of the Spinario next to an inkwell, and his workshop produced a number of versions of this, including one now in the Frick (fig. 9).[16] Slight differences between painted and bronze versions suggest that the Frick's is not the one that Pucci owned. As a category, it represents the many mythological or ancient subjects, such as satyrs or gods, pressed into service to stand next to or hold shells or vases for containing ink or sand for blotting fresh ink. This juxtaposition of statue with functional implement is somewhat awkward, so combining both into a single object, as Riccio's oil lamp does, is a more elegant solution.

Fig. 8
Pierfrancesco Foschi
Cardinal Antonio Pucci, 1540
Oil on canvas
45 11/16 × 34 5/8 in. (116 × 88 cm)
Corsini Gallery, Florence

Fig. 9
Workshop of Severo da Ravenna
The Spinario with Inkwell,
ca. 1500–1520
Bronze
Overall height 6 5/8 in. (16.8 cm)
The Frick Collection, New York

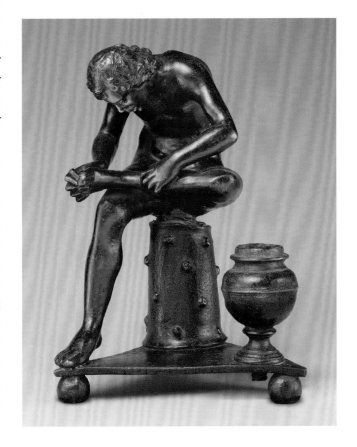

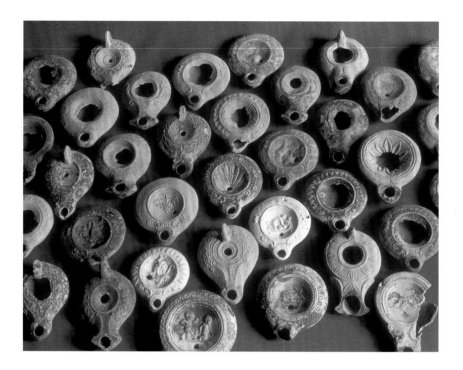

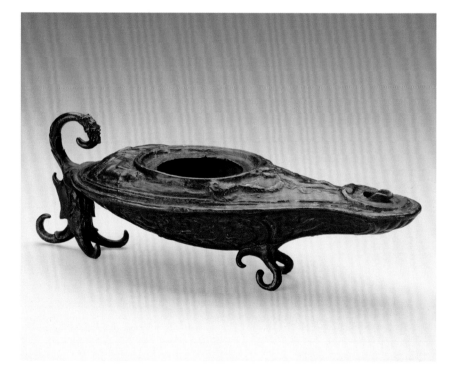

Fig. 10
Ancient Roman oil lamps found
at the Tel Dor excavations

Fig. 11
Andrea Briosco, known as Riccio
Oil Lamp in the Form of a Boat,
"The Fortnum Lamp,"
ca. 1500–1510
Bronze
6⅝ × 2¼ × 2¹¹⁄₁₆ in.
(16.9 × 5.7 × 6.8 cm)
Ashmolean Museum, Oxford

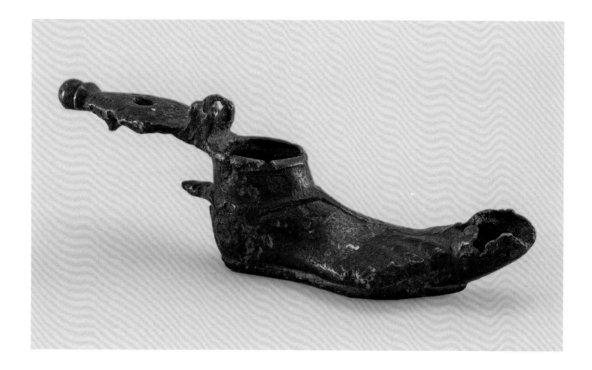

In the ancient world, oil lamps were produced in abundance. These ranged from the simplest and cheapest terracottas (fig. 10)—most often a flat, hollow disk with a handle and a protruding spout (the equivalent of the glass and tin version in my Maine cabin)—to those in costly media, taking zoomorphic, bizarre, or even obscene forms. Riccio did, in fact, fashion an oil lamp after the most basic ancient type (fig. 11), but he added a rudder to turn it into a boat and devised related relief decoration of Charon welcoming a boy onto his ferry to cross the river Styx, thereby elaborating its meaning.[17] As we will see in other works, the artist returned to the theme of oil lamps as ships. The Frick oil lamp, however, takes its cue from another ancient type, that shaped as a sandaled human foot. A second-century Roman bronze in the Musée des Beaux-Arts in Lyon (fig. 12), which holds a large collection of ancient oil lamps, is truncated at the ankle and hollow so that oil flows to a wick pan in its big toe.[18] As we have seen, Renaissance artists often created new versions of ancient precedents. With its circular rim, crisp sandal, and pipe-like extrusion for the flame, a sixteenth-century example in Bologna (fig. 13) refines the disconcerting "hot foot" ancient example for a discerning Renaissance clientele.[19]

Fig. 12
Ancient Roman
Oil Lamp in the Shape of a Foot,
1st–3rd century CE
Bronze
L. 4¾ in. (12 cm)
Musée des Beaux-Arts, Lyon

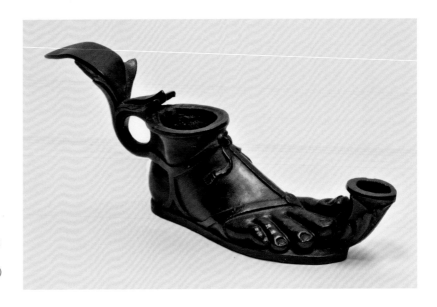

Thanks to a beautiful portrait by Moretto da Brescia (fig. 14), we can see how this particular Renaissance oil lamp figured in contemporary life.[20] Striking a melancholic pose, this wistful young man—his elbow comfortably poised on a pillow, while his arm props up his head—sports a hat badge bearing a Greek inscription that identifies the source of his sadness—in translation, "I desire too much."[21] Some tokens of his desires—for wealth, clothes, knowledge—are strewn across the table beside him: coins, well-made gloves, and an oil lamp from the same model as that in Bologna. Pocketed, worn, or held, these objects could be easily carried about, underscoring the portability of oil lamps, which were not necessarily confined to a study but could be moved wherever light was needed.

Moretto da Brescia's Bergamasque contemporary, Giovanni Battista Moroni, describes another example of a foot transformed into a household object. In this instance, we know the name of the sitter, the poet-scholar Giovanni Bressani (fig. 15).[22] Unlike the foppish young man whose arm is propped on a pillow, Bressani rests his on a stack of books and immerses himself in his work. Reading and writing are his occupation; the script of the papers beneath him flowed from the quill clutched in his right hand. The tools of his trade surround him and underscore this activity: a knife for sharpening the quills, sanders for drying the wet ink, and an inkwell in the shape of a foot. The splotch of ink on the latter's rim hints that it has just been used, and the

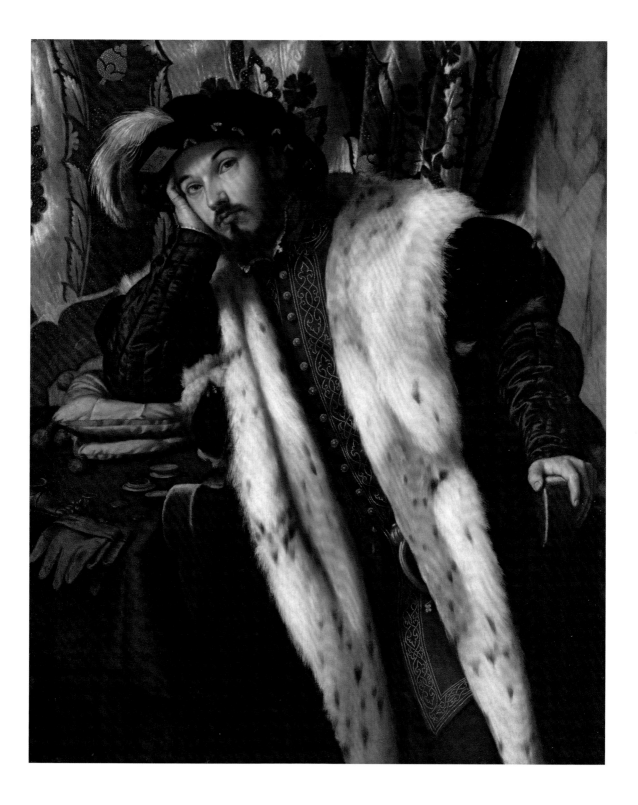

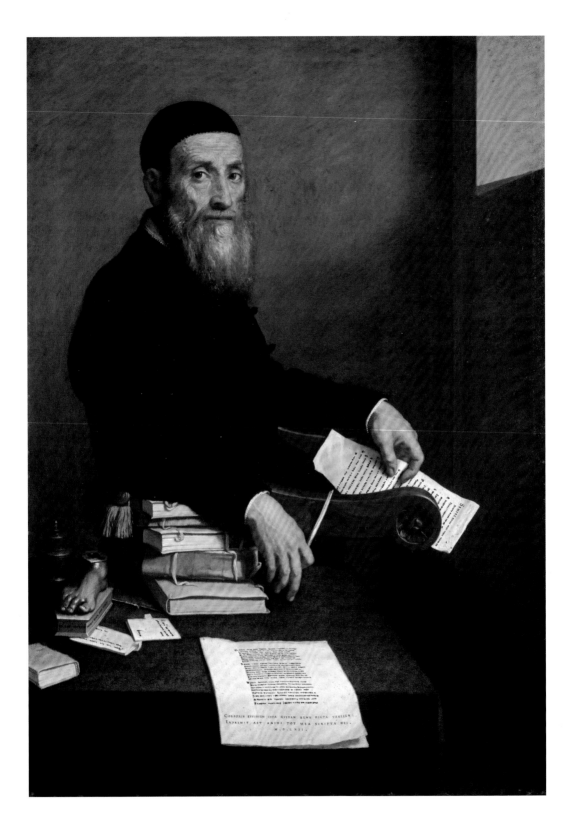

note pinned beneath it signals that it doubles as a paperweight. This object is all the more important as it bears the artist's signature, as well as a Latin inscription (PINXIT QVEM NON VIDIT) that reveals that the painter had not seen the sitter: this is a posthumous portrait.

Daylight streams in through Bressani's window, so he has no need of candles or lamps. Since the bronze foot had multiple functions—connected with both reading and writing—what associations did it carry for Renaissance owners? Ink or oil replaces blood that circulates from head to toe and connotes ideas brought to life through the act of writing poetry or by creating light as a source of clarity and inspiration. It also implies stasis versus movement; the foot is at rest in Moroni's image, not walking, while Moretto da Brescia's lamp has a handle to move it. Furthermore, the Renaissance was not without humor: the foot as paperweight reminds one of the comical act of jumping to step on papers blown away on a windy day. The oil lamp also summons the uncomfortable sensation of resting a foot too long on a hot surface. Not to mention that the very use of a foot for purposes so at odds with anatomy is laughable.

The foot also projects the poetic construct of synecdoche, of a part standing for the whole, as the foot relates to the body of which it is a part. A more literal example of this is a bronze in the Kunsthistorisches Museum, Vienna (fig. 16), which reproduces the Apollo Belvedere's left foot.[23] One of the most famous of all antiquities, this second-century Roman marble copy of a Greek original came to epitomize the beauty of ancient civilization.[24] Better known were full- and small-scale reproductions, as was the case with the Spinario. Yet, for some collectors, Apollo's foot alone could carry the weight of association with this great statue. Tellingly, the choice of the left foot, which in the statue touches its toe to the ground, its heel lifted, conveys the god's gentle movement and graceful poise.

In an era when many antiquities were excavated, fragments of marble and bronze statues—heads, arms, torsos, legs, feet—found their way into collections alongside complete works.[25] Even in their partial state, such works evoked admiration, aesthetically as tokens of

Fig. 15
Giovanni Battista Moroni
Giovanni Bressani, 1562
Oil on canvas
45¾ × 35 in. (116.2 × 88.8 cm)
National Galleries of Scotland,
Edinburgh

Fig. 16
North Italian
Left Foot of the Apollo Belvedere,
early 16th century
Bronze
H. 3⅜ in. (8.5 cm)
L. 5⅛ in. (13 cm)
Kunsthistorisches Museum,
Vienna

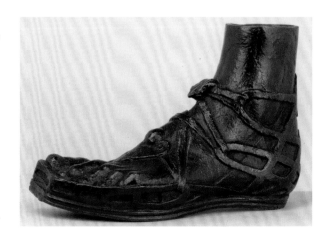

Fig. 17
*Various Ancient Altars and
Sculptures of Body Parts*
Engraving in Montfaucon
1721–22, pages 152–53,
pl. 34

past civilizations rather than bearing a specific meaning as a body part. Yet, there were examples of feet as complete objects, which in the Renaissance were believed to have specific roles in ancient practices. Such interpretations were reflected a couple of centuries later in Bernard de Montfaucon's *Antiquité expliquée*, a compilation of engravings of ancient works from known collections published in fifteen volumes and accompanied by explanatory texts.[26]

In his book, Montfaucon included Riccio's Frick lamp as an antiquity.[27] In a subsequent volume in which he describes a page of illustrations of which the bottom half represents a number of body parts, including feet (fig. 17), the author asserts that these would be consecrated to the gods, perhaps in the hope of, or out of thanks for, being cured of lameness. Models of body parts, such as feet or eyes, and even intestines and uteruses, were offered at healing sanctuaries to thank gods for healing the limb or organ depicted.[28] Among the feet is one completed by a snake wrapped around its ankle, in reference to Asclepius, god of medicine. Montfaucon cites an ancient source "that says that the feet were under the Guardianship of Mercury; but here I must except one that has a Serpent upon it, that being an undoubted symbol of Asculepius [sic], and which seems purposely put there to signify that the foot was consecrated to him."[29]

Montfaucon also connects the serpent-draped foot to Egyptian artifacts. Such cult-like associations led to superstitions and romantic stories taken up by novelists and artists as recently as the nineteenth century. In Théophile Gauthier's *Le Pied de momie* (1840), a mummy's foot bought as a paperweight summoned its owner, a beautiful princess, who hops in pursuit of the hapless souvenir purchaser.[30] Thus, the foot remained a powerful symbol up into the modern era.

If the Renaissance had a wealth of associations with feet and often turned them into implements of practical use, Riccio's oil lamp at the Frick is not simply a sandaled foot but a half boot, absent its foot. When it appeared on the London market in 1910, authors described it as a galley, since it related to two other Riccio oil lamps in the shape of ancient ships.[31] It was only in a Frick catalogue of 1953 that Eric Maclagan changed the identification to that of "a galley or shoe" and wrote that "a shoe is more immediately suggested."[32] The author was unaware that in 1652 Licetus had already described it as "constructam in formam fere calcei," that is, a half boot (*calceus*) as opposed to a sandal (*caliga*). The *caliga* was standard wear for republican and early

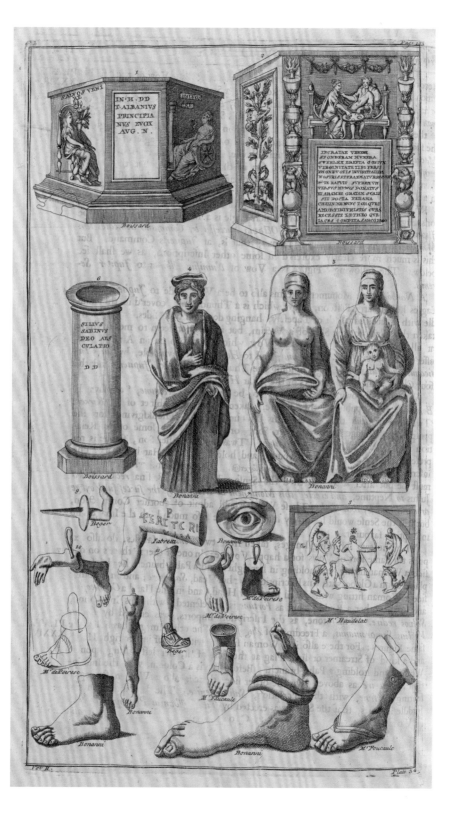

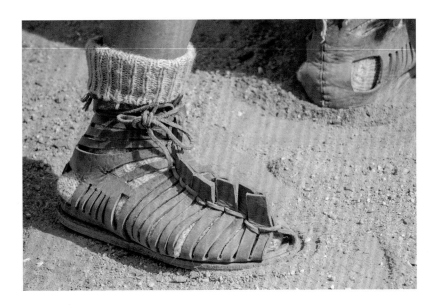

Fig. 18
Modern reconstruction of
ancient *calcei*

imperial Roman soldiers, but, by the Trajanic period, different forms of *calcei*, as seen in a modern reconstruction (fig. 18), were preferred.[33] It is this type of half boot—in a closed, rather than crisscrossed strap version and not hobnailed for protection of the soles in military marches—that Riccio chose. The artist was aware of versions that strapped around the calf, as they are worn by some of his statuettes, such as Orpheus (see fig. 21). As a solid form, the unperforated half boot, however, provided him with a greater surface for his relief decorations.

The Sculptor Andrea Briosco, called Riccio

Symbolic references to feet and boots underlie the choice of this form, but the sculptor's aesthetic sensibility and technical finesse turned this lamp into a work of art. Trained in fine metalworking by his goldsmith father Ambrogio Briosco, Riccio began his career in the northern Italian city of Trent.[34] At some point in his late twenties, he began to specialize in bronze. This was said to be because of a physical ailment that precluded his ability to do delicate work in hard materials.[35] He was better suited to modeling in soft wax or clay that could be cast in bronze. His move in 1492 to Padua, both a religious center and the site of a great university, proved to be crucial to his career. The basilica that protected the relics of St. Anthony, the Santo, drew pilgrims from across Europe. Riccio's greatest work of art, the Paschal Candelabrum,

was commissioned for the center of this holy space. The university, another source of patronage, attracted students from many countries to pursue various disciplines and was noted for its pursuit of knowledge gleaned from ancient texts. From these writings, readers knew the esteem in which bronze—an alloy of copper, tin, and other metals—was held in the classical world. Eager to own works of art that reflected or commented on themes from ancient literature and history, patrons sought out Riccio's bronze statuettes inspired by the antique.

A closer look at several of Riccio's best-known sculptures reveals his artistic character, as well as his devotion to ancient themes. The dream of Arcadia and its mythological inhabitants seduced artists and patrons in the Renaissance. The *Drinking Satyr* (fig. 19) in the Kunsthistorisches Museum in Vienna is perhaps the finest of several variations Riccio executed on this subject; the others are in Padua (Musei Civici degli Eremitani) and Paris (Louvre).[36] Half man, half goat, the satyr belongs to a world evoked by ancient writers like Ovid or seen through contemporary ones. Thus, Ovid's tale of Pan's love for the nymph Echo in the *Metamorphoses* (Book III) is renewed by Angelo Poliziano in the *Miscellanea*, first published in Venice in 1489.[37] A bronze statuette after a model by Riccio, entitled *Inkstand with a Faun, called "Pan Listening to Echo,"* indicates the artist's familiarity with such ancient myths.[38] In similar fashion, the Renaissance sculptor based his image of the satyr on ancient prototypes but translated these into a modern idiom. Above the waist, this mature man has defined, if flat, chest muscles and a tight waist; but below, he changes, his legs appearing shorter than a man's, sprouting shaggy hair and ending in cloven hooves. Goat horns spring from his luxurious head of hair.

This is a figure of lust—drinking from a cup, exposing his genitals— though his expression is not inebriated or lascivious but rather somewhat melancholy, perhaps conscious of his divided nature. The satyr expresses the tension between the human and the animal combined in this hybrid creature, a higher sense of morality warring with base desire. The statuette has been beautifully composed in the wax model that was the basis of the bronze; but characteristic of Riccio is the hammering of the cast bronze's surface, a texture that glints in the light. The sculptor's working of the metal after it has been removed from the mold extends to details like the string of punch marks separating tufts of hair on his calves. For Claudia Kryza-Gersch, these recall the drill holes on ancient marble sculptures.[39]

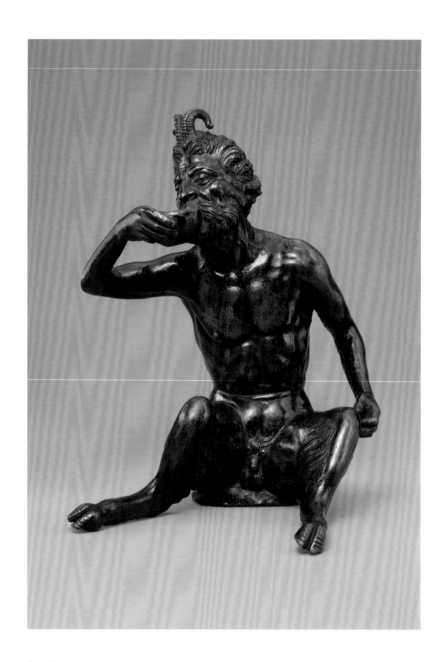

Fig. 19
Andrea Briosco, known as Riccio
Drinking Satyr, ca. 1515–20
Bronze
H. 8⁹⁄₁₆ in. (21.7 cm)
Kunsthistorisches Museum, Vienna

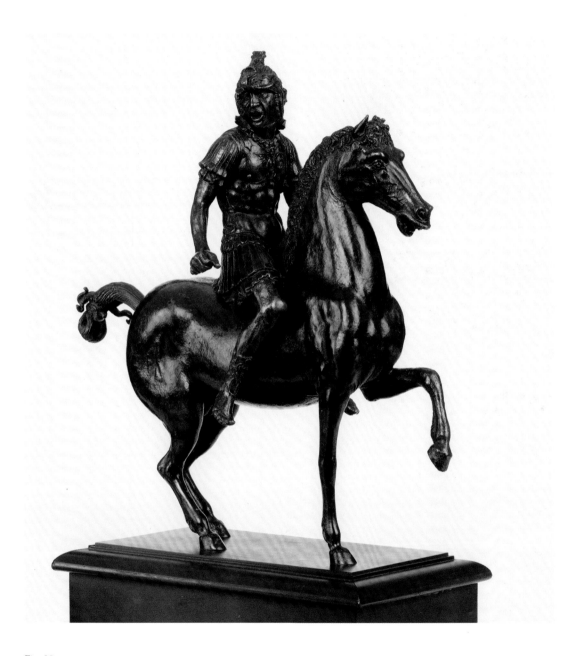

Fig. 20
Andrea Briosco, known as Riccio
The Shouting Horseman, ca. 1510–15
Bronze
H. 13 in. (33 cm)
Victoria and Albert Museum, London

Fig. 21
Andrea Briosco, known as Riccio
Orpheus, ca. 1510–30
Bronze
9¹⁵⁄₁₆ × 4¹¹⁄₁₆ × 5⅜ in.
(25.2 × 11.9 × 13.6 cm)
Musée du Louvre, Paris

Wax models offer the potential of creating multiples of the same composition. In Riccio's time, this technique led to workshops producing a number of good, as well as mediocre, copies; later, in the sixteenth century, sculptors like Giambologna and followers like Gianfrancesco Susini took this replication to a high level of sophistication in precise, finely rendered copies that are only subtly different one from another.[40] In Riccio's work, his artistic personality led him to seek fresh interpretations whenever he created a variation of an existing model. So in the related bronze in Padua, he has removed the horns, and the eyes close in response to drinking, while the legs curl upward; the one at the Louvre retains the pose of the legs, but the left arm is raised from the knee, and the face is less creased with age. With small but telling changes, the sculptor sought to particularize every work that passed through his hands.

An undisputed masterpiece of the Renaissance is *The Shouting Horseman* (fig. 20), a foot-high bronze in the Victoria and Albert Museum.[41] It is a tense, vivid description of a rider and his mount, poised for action, perhaps to spring into battle. The warrior's mouth, open in a scream, matches the horse's startled eyes and taut neck. The artist relates human to animal reactions, as each responds in a manner appropriate to its species, yet join as one in purpose.

Of interest for the half-boot oil lamp is Riccio's close attention to military costume. This is a fantasy of an ancient Roman warrior—though some commentators have cited passages from the ancient poet Statius as a starting point for Riccio's conception of the subject.[42] It is also a timeless depiction of man at war. Light cavalry of the early sixteenth century rode bareback and wore only helmet and breastplate rather than a full set of armor, which had been the norm a century earlier. Riccio clearly studied images of ancient mounted soldiers, such as those circling the famed Roman monument Trajan's Column.[43] The rider's molded leather or metal breastplate, shaped like a human chest, and the pteruges protecting his thighs reflect such models. Yet the helmet is an elaborate and fanciful Renaissance concoction with curling horns, scallop shells, and figural reliefs, reminiscent of the extraordinary productions of the Negroli family of Milanese armorers, who reserved such work for their wealthiest clients' parade armor.[44] The high boots are equally decorative with grotesque faces at their top but ending in open sandals since heavy soles were not required for cavalry.

One final bronze brilliantly expresses Riccio's response to the ancient world. The legendary musician Orpheus's playing and singing charmed all

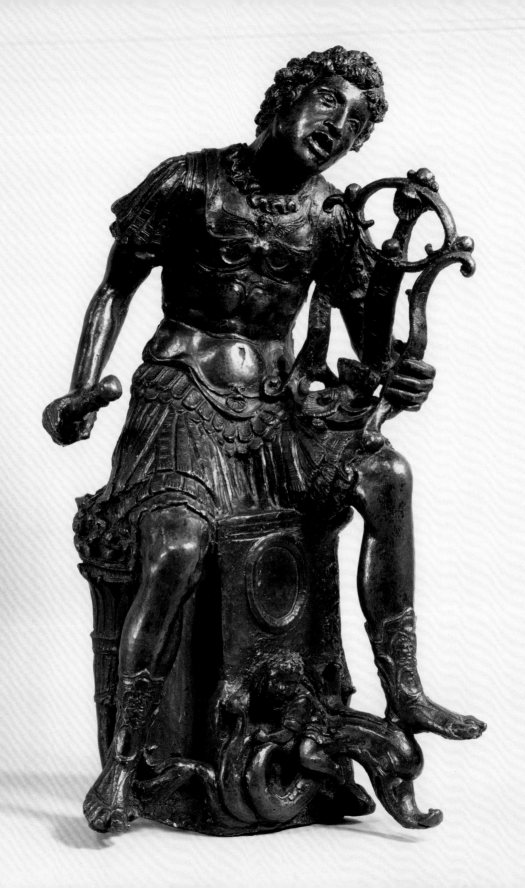

Fig. 22
Andrea Briosco, known as Riccio
The Paschal Candelabrum,
1507–16
Bronze
H. 13.12 ft. (4 m)
Basilica del Santo, Padua

audiences, animate and even inanimate (fig. 21).[45] He is seldom depicted wearing armor.[46] Yet this is Riccio's concept, as the bard sits open-mouthed in song, leaning forward to strum his lyre. Like *The Shouting Horseman*, Orpheus wears an elaborate cuirass and high boots, though, unlike him, he is helmetless. Once again, this is a fantasy of the ancient world, as if Riccio could not resist the temptation to redesign ancient garb. It is a singular interpretation, as are many of the sculptor's works, and a fresh approach: reinventing a subject frequently depicted by artists, and transforming it into a memorable statuette, which elicits our thoughtful attention. In the hands of a lesser artist, the elaborate surface decorations could overwhelm its subject. Riccio's intense focus on the singer and his action holds our gaze, and the relief details only add to our pleasure as we slowly circle around it.

The Paschal Candelabrum

Riccio's most celebrated work, the magnum opus that occupied him over the course of a decade, is the Paschal Candelabrum (fig. 22), commissioned in late 1506 and installed in 1516. The candelabrum had a lengthy gestation and execution, making it difficult to assess when Riccio was at work and on which parts. The council of the Arca del Santo voted to replace an earlier wooden candelabrum on December 18, 1506, but Riccio's contract for it was only signed in June of the following year.[47] The finished work—absent some gilding—was set in place in the choir in 1516. In between, the War of the League of Cambrai (1508–16) is known to have impeded work, forcing Riccio to move his unfinished components for their safety, so it is unlikely that he could attend to it continuously. Nonetheless, the start and finish dates offer reasonable, if hypothetical, guidelines for dating the oil lamp.

Originally, the candelabrum occupied the center of the choir of the Basilica del Santo, but it was later moved to the side of the main altar, where it remains to this day. Lit to celebrate Easter, it is still in liturgical use. Like the oil lamp and many of the sculptor's works, it is a functional object. At just over thirteen feet high, it dwarfs all of his other works, yet, as we shall see, many of its figural and decorative motifs bear closely on his smaller objects.

The candelabrum was the final element of the choir decorations, which occupied three generations of sculptors.[48] Its style and meaning are linked to the sculptures that preceded it and filled the same space. Donatello, the greatest and most creative sculptor of the early Renaissance, was responsible

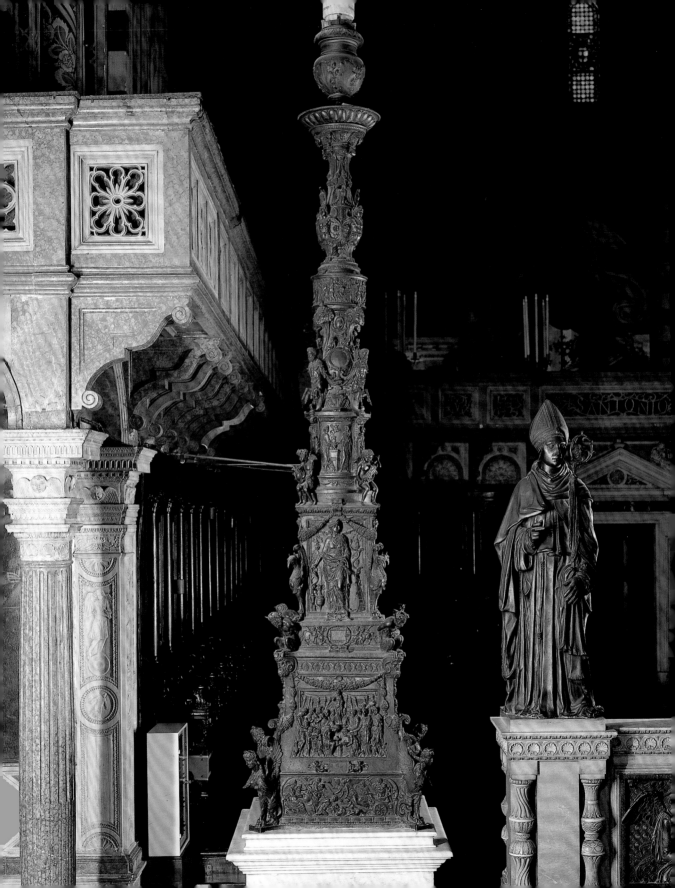

Fig. 23
Bartolomeo Bellano
Samson Destroying the Temple of the Philistines, 1484–90
Bronze relief
26 × 32⅞ in. (66 × 83.5 cm)
Basilica del Santo, Padua

for the set of eight bronze statues of the Crucified Christ, the Virgin and Child, and other saints that crowned the high altar (1443–53). However, it is less the stately and contained saints in the Santo than Donatello's dramatic reliefs and expressionistic smaller works that influenced Riccio, as they did many artists in his wake. Among those were Bartolomeo Bellano, who was responsible for important reliefs in the Santo, such as *Samson Destroying the Temple of the Philistines* (fig. 23). The illusion of chaos and destruction, as the loge crumbles and the crowd tumbles, drew lessons from the sense of drama of Bellano's master Donatello; yet the younger sculptor's work has a symmetry and narrative force, as well as a gentler and more intimate quality seen in his smaller works, that resonated with Riccio. Since the latter was in turn Bellano's assistant, there is a clear chain of influence through the work of these three sculptors active in the Santo over seventy-five years.

Donatello's statues on the altar took their subjects from the New Testament, and Bellano's relief subjects were drawn from the Old Testament. The candelabrum, however, juxtaposes or merges Christological with classical themes in arcane allegories conceived by the interconnected circles of the church and the university in Padua.[49] In an effort to reconcile antiquity with Christianity, its program links Christian theology with Greek philosophy and eastern religions through Neoplatonism, reflecting the heady mix of academic and theological studies pursued in the city. The focus of fascination and intense scrutiny, the candelabrum's multiple meanings continue to be discussed and debated.[50] Of particular interest to us is the relation of some of its components to Riccio's oil lamp.

Complex and dense with imagery, the candelabrum comprises seventeen reliefs and sixteen statuettes. The cylindrical drum at about the midpoint of this tall shaft shares aspects of the lamp (fig. 24). The imagery completely circles the drum with rectangular reliefs on the four principal faces, much as the central long relief turns around the oil lamp. The reliefs' meaning has been variously interpreted, but Davide Banzato has made a convincing case for reading them as personifying Poetry, Theology, Philosophy, and Fame.[51] The figures flanking an altar, for example, would thus represent the Muses, with the winged horse Pegasus as the source of Poetry. The oil lamp reliefs also present a sacrifice. The four winged putti sitting at the corners of the candelabrum drum hold musical instruments, a mask, and a mirror, which may bear on the reliefs' subjects. Similarly, the oil lamp once held music-playing putti,

Following pages:

Fig. 24
Drum section of the Paschal Candelabrum with flanking putti (detail of fig. 22)

Fig. 25
Cylindrical section of the Paschal Candelabrum with frieze of Bacchic procession (detail of fig. 22)

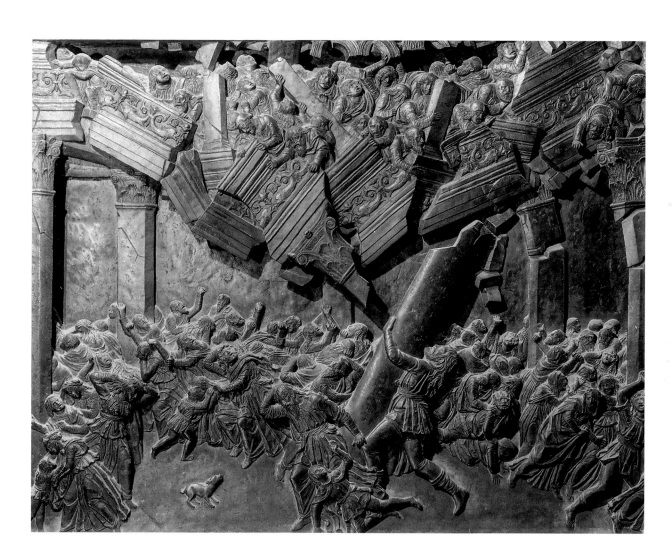

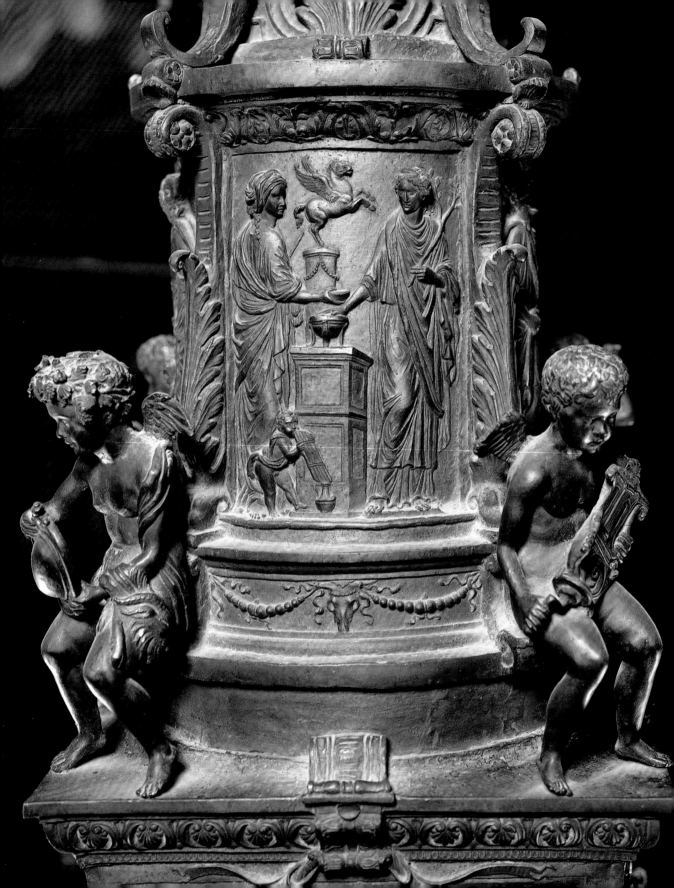

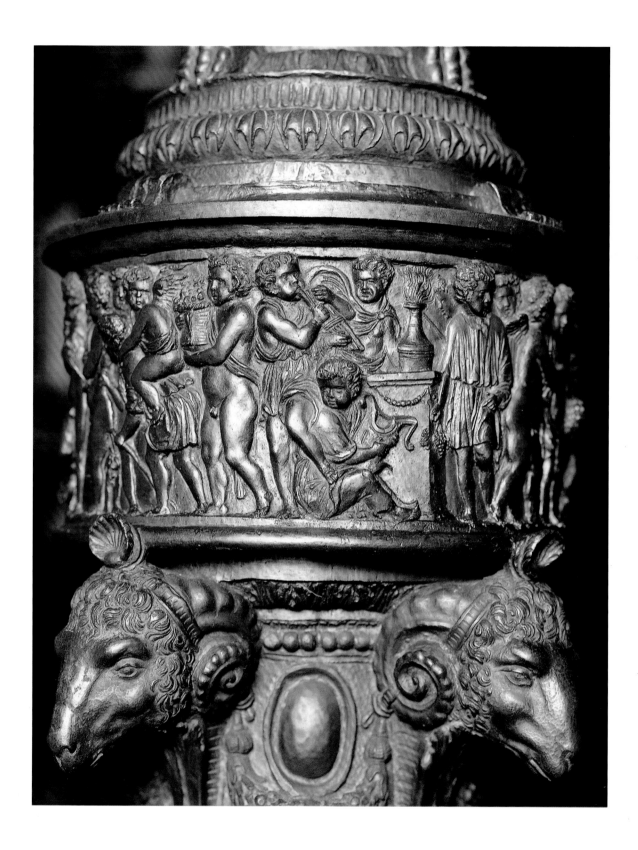

though apparently not winged, which were fully three-dimensional statuettes related to the imagery of the relief below. Other decorative motifs, like the ox skulls tied by garlands, are to be found surrounding the oil lamp spout. Finally, the overall decoration of candelabrum and oil lamp share an attitude of *horror vacui*, as the sculptor was loath to leave any surface unembellished. This richness and complexity constantly engage the viewer, never releasing the intertwined motifs into resolution.

Further up the candelabrum shaft is a smaller drum with a continuous frieze of a Bacchic procession (fig. 25). Very much as in the oil lamp frieze, the children play musical instruments and carry masks and other offerings. A sacred fire burns at an altar. The ecstasy of Bacchic rituals has been interpreted by some as a parallel to that of the worshipper inspired by God, the kind of analogy that preoccupied Neoplatonist thinkers of the period.[52]

Riccio's compositional principles, associations of meaning, and some specific motifs closely relate the candelabrum to the oil lamp. It seems likely that the Frick oil lamp was conceived, though at a much smaller scale, during or shortly after the period when the sculptor was engaged in this major commission for the Santo.

Riccio's Oil Lamps

Riccio made several oil lamps, and two of these are conspicuously related to the Frick's in their complexity and elaboration. By comparing them, we can better understand how he conceived their forms and meaning, as well as deduce what is missing from ours. Both of the related examples take the overall shape of ships; for this reason, the Frick oil lamp was misidentified as a ship in the early twentieth century.

Why a ship? There are precedents, though rare, of ancient oil lamps in the shape of ships.[53] In the Renaissance, they were often the basis of decorative forms. Many jeweled pendants centered on masted ships, colorfully enameled over precious metals and sometimes incorporating gems like emeralds, which were transported in the holds of Spanish galleons from the New World to Europe.[54] Thus, a ship could symbolize the wealth it carried back to its owners. At the same time, it could stand for fortune, good or bad, as a shipwreck could ruin the careers of those who had invested in its safe and profitable return. By extension, a ship connoted rank, as power and wealth were intertwined. From the Middle Ages onward, banquet tables often featured a nef, an elaborate

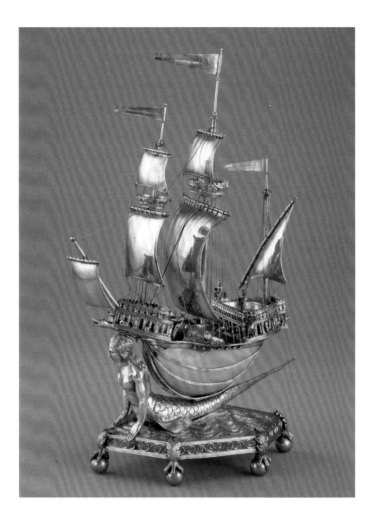

Fig. 26
French
The Burghley Nef, 1527–28
Silver, enamel, and nautilus shell
13¹¹/₁₆ × 8³/₁₆ × 4¹³/₁₆ in.
(34.8 × 20.8 × 12.2 cm)
Victoria and Albert Museum,
London

centerpiece fashioned from silver and other precious materials. Its "cargo" was
salt, a product of the sea, or table utensils, and it would be placed before the
most important guest or the host of the table.[55] The Burghley Nef (fig. 26) is a
spectacular French example of the type, its nautilus-shell hull supported by a
silver-gilt mermaid, while miniature sailors clamber up its sides and rigging.[56]
A decorative ship's hold was designed to contain precious freight—whether
salt or oil—and it implied movement. The owner of the nef or oil lamp could
pass it along for others to enjoy its condiments or its light. Similarly, the half
boot is a container, generally of a human foot, though it could serve when not
worn to store other materials, and it too suggests motion since a shoe protects
its wearer when walking.

The simplest, if largest, of these related ship oil lamps is the Cadogan Lamp (fig. 27), now in the Victoria and Albert Museum but named for a previous owner, the Earl of Cadogan.[57] Its prow forms the wick pan, from which a tongue protrudes. Beneath it is a pointed rod or battering ram for naval battles, which protrudes from the keel. Contravening shipbuilding design, the keel curls down at the prow in a single strut and at the stern projects into two, forming a tripod to support the oil lamp. At the stern, the rudder terminates in a head with puffed cheeks—a wind god—and continues up to an element that must have been the tiller. Like the Frick's lamp, this is broken, but it is likely that this arced toward the front to provide a handle for moving or hanging. On the poop deck are traces of the emplacement of the helmsman who held the tiller and piloted the ship.[58] Continuing amidships is the lid—missing from the Frick example—which is topped by a winged putto riding a dolphin, whose tail twists up to form the handle for lifting the lid, hinged to the aft deck. Surprisingly, the sea creature swims against the direction of the ship.

As is the case with the Frick lamp, the ship's sides are covered with relief decoration. In keeping with the maritime theme, tritons and nereids squeeze into a tight space along the bulkheads, while grotesque female figures, their lower limbs tapering strangely into feathers or faces, fill out the stern. On each side, surrounded by sea creatures, is a medallion, featuring, on the port side, a seated figure tied to a tree stump and blowing into a sail, and on the starboard, an obese, naked woman seated on a globe and holding scepter and rudder. She is flanked by clothed younger women: one holds a branch or flail and a bucket, the other money bags.

Both of these roundels are so prominent and their figures so explicitly depicted that they suggest specific interpretations. The images connect loosely to the seafaring motifs of a ship: one features a sail, the other a rudder. Interestingly, their models are from Renaissance sources rather than generic classical forms, and this helps to identify the subjects. The most recognizable (fig. 28) is the frustrated sail-blower, who represents "Festina Lente" (Make Haste Slowly), a motto popular then and still proclaimed by some institutions today.[59] The idea that one should take time to deliberate and then act quickly, that speed is countered by steadiness, may be traced back to Aristotle's *Nicomachean Ethics*.[60] It was taken up in the Renaissance by such writers as Desiderius Erasmus and often featured in woodcuts and engravings of the

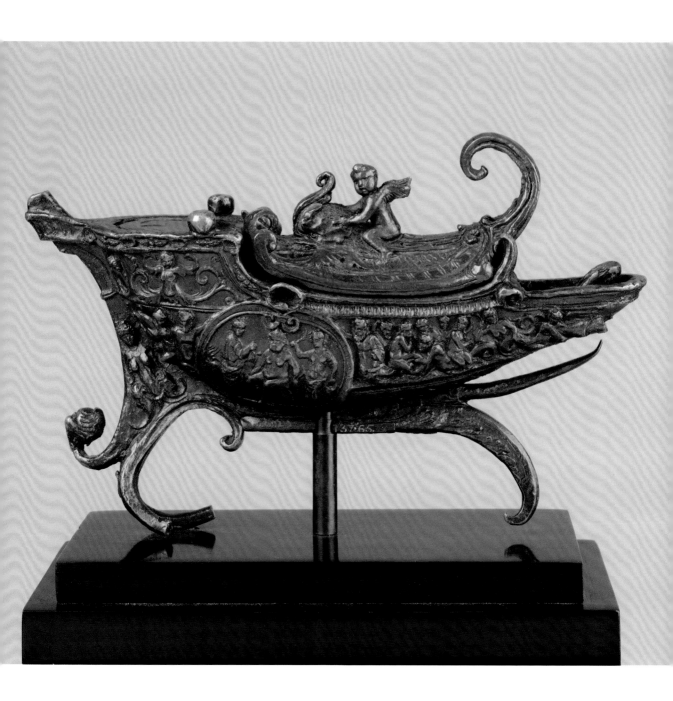

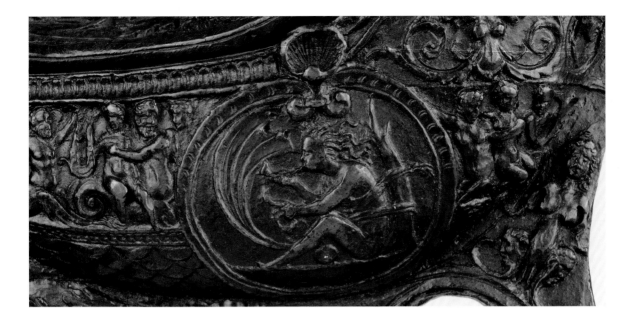

Fig. 28
Detail of the Cadogan Lamp
(fig. 27)

time. Could the lid finial of the dolphin held back by its handle be a gloss on this idea? The trademark of the Aldine Press, which published Erasmus, among others, was a dolphin and an anchor: this combination of speed and restraint hints at the connection between lid finial and the circular image.[61]

The other medallion has been shown to derive from Andrea Mantegna's drawing of the *Allegory of the Fall of Ignorant Humanity*, later engraved by Giovanni Antonio da Brescia about 1500–1505. It has been interpreted to be Ignorance guided by Fortune—represented by the unstable globe on which she sits and the rudder that sets a direction—rather than by Virtue, in order to achieve prosperity.[62]

These moral messages are so pointed that it seems likely that they were requested by the person who commissioned the oil lamp. Their presence makes one speculate about the degree to which such moral injunctions are implicit, if less overt, on the other oil lamps.

The most complete of the three oil lamps resided for many years in the collection of the Rothschild family in France and is often referred to as the Rothschild Lamp, although it has recently been acquired by the Metropolitan Museum of Art (fig. 29).[63] Like the others, it is a functional source of illumination. It still retains its lid, now sporting two naked children leaning on sea creatures, whose tails rise up behind them and trail back into the water.

The lid's handle is an extravagant creation, a winged creature that twists out of the front and terminates in an outsized grotesque mask. Facing the spout, its mouth opens as if to blow on the flame beneath it when the lamp is lit. All the lamp's thin curling elements survive. Out of the stern of this galley-shaped vessel a long rod twists toward the prow, terminating in a ram's head (acting as a stop beyond which the lid cannot be opened). The rear elements appear to be tendrils sprouting from an encasement of leaves. Together with the massive swags of foliage hanging from the bottom of the galley, Riccio appears to consider these metal curls as organic shoots rather than the ship's keel extrusions on the Cadogan Lamp or what may be shoelaces on the Frick's. These different interpretations accord with the sculptor's spirit of invention, never repeating himself exactly but finding a fresh approach each time. Beneath, the tendrils form a tripod, like that of the Cadogan Lamp, on which the lamp can stand.

Its body centers friezes of twelve naked children on one side, eleven on the other, dancing or playing pipes and horns. At each end, they kneel or sit around a ram. Their poses adapt to the tapering form of the frieze: seated at one end and fully standing at its tallest extent. By contrast, the Frick lamp's frieze has a consistent height and continuously circles the lamp body, though it is partially interrupted by a male bust at the front. It also implies a narrative—the preparation for a sacrifice and its aftermath—while the Rothschild Lamp essentially repeats the same scene on each side. The convex sides of the Frick lamp accentuate the bulging bodies of the children, while the flat sides of the Rothschild Lamp silhouette their poses and emphasize the children's activity through angled limbs.

The overall shape leaves less room to develop other ornament. The bottom of the hull bears a simple alternation of scallops with foliate patterns. The gunwales are articulated only with parallel vertical lines. It is less obviously a ship than the Cadogan Lamp, which is clearly identified by rear deck, keel, and rudder. Would we even recognize it as such were its galley shape not so close to the other lamp? Its rear, or stern, features a medallion of two seated putti facing each other, seemingly without a particular allegorical context, and a wide grotesque head beneath faces the opposite direction from the one at front. The ship's hull leaves little room to elaborate its underside. Of the three, the Frick lamp is the only one that has been consistently articulated on all sides and has a continuity of forms around its surface.

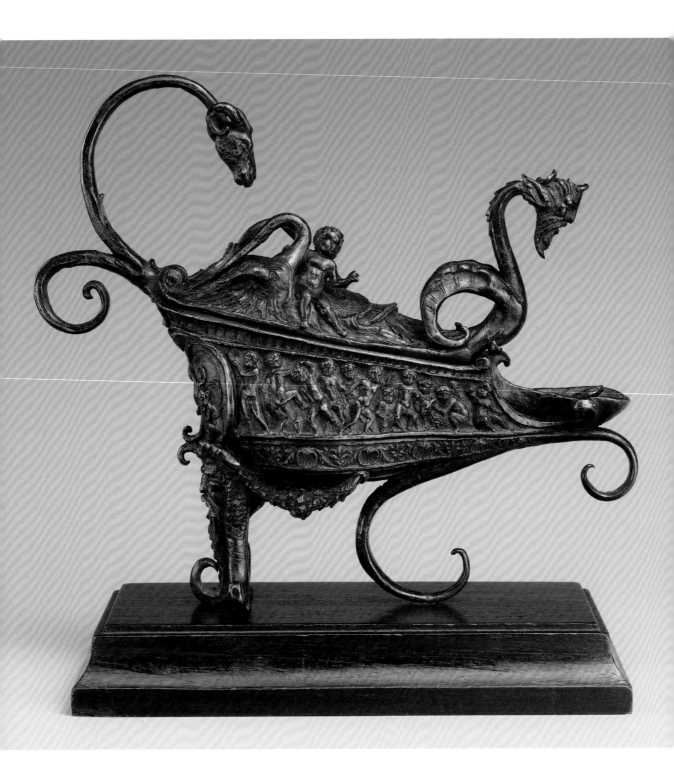

How much common ancient motifs like *bucrania* and garlands were intended to hold meaning for Renaissance viewers is an open question. Peta Motture cites an October 1546 letter from the sculptor Vincenzo Grandi to Cardinal Cristoforo Madruzzo in Trent. Describing a bronze inkwell he had sent to the cardinal, the artist writes that the ox heads "signify the hardship on which glory depends" and the garlands "stand for no less than the triumphs of virtue and the honor of glory."[64] Some of the mood suffusing Francesco Colonna's wildly popular *Hypnerotomachia Poliphili* (1499) may underlie Riccio's approach to the oil lamps.[65] In this complex tale of a dream, Poliphilo and his love Polia sail on a ship. The book's woodcut illustrations of triumphal carriages and arcane symbolism present challenges to the reader of identifying ancient scenes and deciphering their contemporary meaning similar to those confronting the viewers of Riccio's oil lamps.[66] In one passage, the heroes discover an ancient marble bridge covered with "Egyptian hieroglyphs [fig. 30] depicting the following: an antique helmet crested with a dog's head, an ox skull with two fine-leafed branches tied to its horns, and an ancient lamp. I interpreted these hieroglyphs . . . as follows: Patience is the ornament, Guardian and protector of life. On the other side I saw this elegant carving: a circle, and an anchor around whose shaft a dolphin was entwined. I could best interpret this as: . . . Always hasten slowly." It is interesting to see an ancient oil lamp itself as a symbol, a protector of the flame of life, and connected to the dolphin and anchor emblem of "make haste slowly," which has been associated with Riccio's oil lamps.

Fig. 29
Andrea Briosco, known as Riccio
The Rothschild Lamp,
ca. 1510–20
Bronze
7⅝ × 9 × 2⅞ in.
(19.4 × 22.9 × 7.3 cm)
The Metropolitan Museum of
Art, New York

Fig. 30
Francesco Colonna
Egyptian Hieroglyphs
Woodcut in Colonna 1999,
f. d7 recto

While these are valuable examples of a contemporary explanation of symbols, Riccio may not have attached specific meaning to his version of these decorations so much as intended them to carry multiple associations with the ancient world and offer various interpretations.[67]

Considering the Three Oil Lamps Together

What do these comparisons tell us about the Frick lamp? The Cadogan and Rothschild lamps suggest that its missing lid featured figures, but we have no idea whether the motif of boys on sea creatures extended to this one too. Aquatic animals are clearly related to a ship but less obviously to a boot. One of the winged figures belonging to Aphrodite's retinue, the Erotes, directing a dolphin, nonetheless, has other meanings. Scholars have pointed out that this frequently symbolizes "Omnia Vincit Amor" (Love Conquers All) and therefore could be viewed independently of any maritime meaning.[68] The connection of love and passion to the flame of life flickering from a lamp makes it a suitable accessory in this instance. Yet the sculptor's penchant for variety suggests that it would have been unlike the other lids, if a rendering of this motif at all, and perhaps represented a different subject altogether. There are signs that a figure stood by the tiller, and it would make sense that this was a helmsman, steering the Cadogan ship, but there are no such figures on the Rothschild one. The latter is certainly surcharged with form—the boys on the lid, the ram's and grotesque heads—leaving little room for others. From the Licetus engraving, we know that a lyre-playing boy sat at the rear of the Frick lamp. It is tempting to imagine that the missing figure at front, evidently standing, also played a musical instrument so that the lads on top harmonized with the musicians in the relief below. If this is the case, could he have played a horn or pipes, blowing on the wick's flames in the same way that the grotesque head on the Rothschild Lamp does?

The figure atop the Cadogan Lamp reinforces the conceit that it is a ship guided by sailors, much like those on the Burghley Nef. Musicians have no such agency on a boot, but the scale of such figures on an elaborately decorated vessel call to mind the fancifully ornamented parade floats that were pulled through Renaissance cities in triumphs or processions.[69] Frequently, these bore elaborate mythological themes extolling the virtues of rulers and would be ridden by actors dressed as satyrs or ancient gods. At various points in the parade, the procession would stop before equally decorated temporary arches or

municipal buildings, and a brief play would be enacted or text read to explain the significance of each float. Riccio's oil lamps with figures oversized for a ship and surcharged with ornaments are in the spirit of these festival decorations.

It is not possible to date any of these oil lamps with precision. Many visual connections between the candelabrum and the Frick oil lamp make it reasonable to assume that the oil lamps were created around 1506–16, when Riccio worked on the major commission for the Santo. His propensity to shift and vary motifs from one lamp to another complicates the question of dating. But can we deduce the order in which they were made? In Anthony Radcliffe's magisterial article on all of Riccio's oil lamps, he places the Cadogan first, the Rothschild second, and the Frick last.[70] He sees increasing complexity of design through the series and a refinement and precision in the Frick lamp that surpassed the others. He also points to the handling of the friezes, fitted into awkward shapes and subordinate to the overall design scheme in the Cadogan and Rothschild ones, compared to the maximization of space and fully sculptural realization in the Frick's. At the same time, he extolls the clarity of design in the Rothschild Lamp and finds its vigorous finishing surperlative.

It does seem likely to me that of the two ship lamps the more literal Cadogan came first and the more abstracted Rothschild later; that is, the sculptor worked through the specific iconography of a ship first and then felt free to vary it later. The Cadogan reliefs—though beautifully realized— are the most ungainly in their adjustment to the ship's side; the medallions are unconvincingly integrated, and the harpies at the stern almost seem to be afterthoughts. The Rothschild one is more symmetrical and carefully considered, though, as the one complete lamp, it is the only one that permits us to see how all the parts coalesce. The frieze of children on the Frick lamp is certainly the best resolved in relation to the overall form and in its sculptural roundness. It is also clear that Riccio took advantage of the plump boot form, not only to accentuate the central relief but also to consistently continue the decoration on the underside of the lamp. This acknowledges that the lamp would be seen from beneath, especially if hung on high, though the socle mitigates this view. Did he add this sturdy support because the tripod devices on the other two proved to be unsteady?

Of them all, it is also the most freighted with ornament, approaching a visual surfeit. One could argue that the structural clarity of the Rothschild Lamp would have been the final stage of development. I prefer to think that

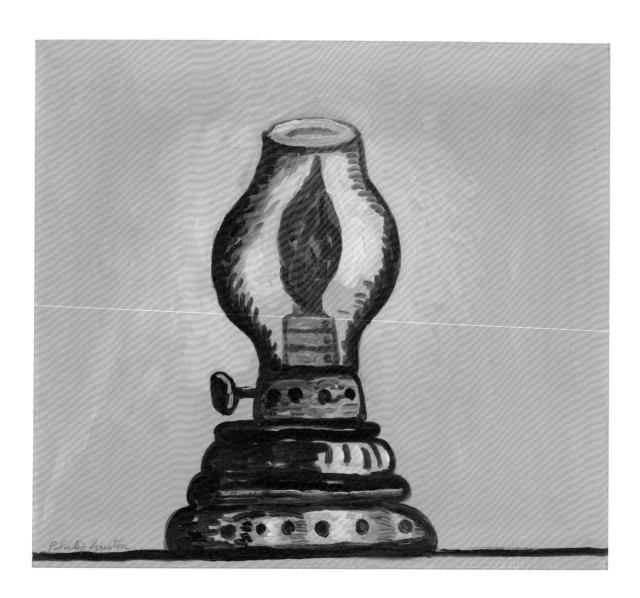

his switch from ship to boot inspired him anew and loosened his creativity in piling on even more complexity and decoration, certainly a hallmark of his style.

What the oil lamps reflect is Riccio's infinitely fecund imagination. He plucks out classically inspired themes and motifs from his repertoire, never exactly repeating himself, and combines them in ways that shift from one lamp to another. The forms themselves seem to morph and change across the surfaces or blossom in unexpected ways. A tendril blooms not as a flower but as a grotesque head; a ram's head has a role in a Bacchic relief but reappears as a finial at the end of a handle; a ship's rudder ends in a wind god's head, blowing the vessel forward rather than plowing through the water. From lamp to lamp, too, he shifts, centering the meaning of one on roundels, then on matching friezes, then on a continuous frieze. Decorative motifs, such as harpies, change from lamp to lamp, none repeated. He takes pains that his lamps have variety, no two alike. The sense of motion suggested by the very shape of ships or a boot was enhanced by the flickering light of the flame; as it played over the lamps, it must have made the children seem to dance before the viewer's eyes. The ship's prow doubles as the lamp spout. Within this is a tongue, suggesting in turn an animal's mouth. This playful transformation of shapes—ship's prow, lamp spout, animal mouth—also calls to mind a different sort of metamorphosis, wordplay. Riccio seemingly puns on the Latin word *rostrum*, which can mean both ship's prow, as well as lamp spout, but also refers to the muzzle of animals.[71]

The sculptor's fondness for mutability suggests that he was not seeking a unified program or a specific iconographic reading as much as he wished to encourage multiple allusions. The lamp's flame sheds light on what surrounds it and pierces the darkness. At the same time its flickering suggests its transience and, by extension, reminds us of the fragility of life. Such meditations continue in contemporary artist Philip Guston's *Lamp* (fig. 31). Painted shortly before his death in 1980, it nostalgically replaces the often-depicted motif of light bulbs with a kerosene lamp, which reads poignantly as symbol of both hope and finality. Late at night, burning the midnight oil, the bronze lamp's owner could follow different trains of thought at whim: from ancient ideas to modern ones, from music to poetry, from Bacchic to Christian sacrifice, from the light of knowledge to the flame of love—in all of these musings, reminded of the constancy of change.

Fig. 31
Philip Guston
Lamp, 1979
Oil on canvas
32 × 36 in. (81.2 × 91.3 cm)
Private collection

Notes

1 Licetus 1652, 753–56. The Licetus connection is discussed by Pope-Hennessy and Radcliffe (1972, 49); see also D. Allen in New York 2008–9, 182–85.

2 P. Motture in New York 2008–9, 190–93, no. 15.

3 Warren 2021.

4 Bode's career and influence is extensive and has been studied in depth. His influential *Die italienischen Bronzestatuetten der Renaissance*, first published in three volumes in Berlin in 1907–12 (volumes 1 and 2 in 1907), was translated and updated in Bode 1980.

5 My thanks to Giulio Dalvit for his research and observations on Campesio. On the Benavides collection, see Favaretto 1972; Favaretto 1980; Favaretto 1990, 108–15; Favaretto 2013.

6 Pesenti 2001.

7 As evidenced by Grandi 1670, 106.

8 For a full account of the Duveen Brothers' relationship with American clients in the early twentieth century, and in particular for the sale of Morgan's bronzes to Frick, see Vignon 2019, 225, 236.

9 The Frick has presented a number of important Renaissance bronze exhibitions based on our preeminent collection, notably, monographic shows on major masters of bronze—Riccio (2008–9) and Antico (2011–12)—organized by former curator Denise Allen. The institution has continued this undertaking with a more recent exhibition on Bertoldo di Giovanni (2019–20).

10 Baudelot de Dairval 1686; see V. Benedettino in Munich 2019, 124–26, no. IV.6. My thanks to David Ekserdjian for bringing this reference to my attention.

11 Thornton 1998b.

12 Thornton 2001. See also Washington, Los Angeles, and Chicago 1986, 91–93, no. 12.

13 This topic has been fully explored in Syson and Thornton 2001. The installation of bronze statuettes that opened at Frick Madison in 2021 lines shelves with bronzes in a recreation of their presentation in Renaissance scholars' studies.

14 Thornton 1988a, figs. 97, 99.

15 Haskell and Penny 1981, 150.

16 Pope-Hennessy 1970, 145–47.

17 See J. Warren in New York 2008–9, 202–7, no. 17.

18 Musée des Beaux-Arts, Lyon (inv. L. 256), l. 4¾ in. See Boucher 1967–71, 253, fig. 12.

19 D'Apuzzo (2017, 92–98, no. 23) identifies this as Paduan, beginning of sixteenth century, and lists variants.

20 Thornton (1998a, fig. 104) identified the bronze oil lamp in the London painting.

21 For a summary of the proposed change of dating of the painting from the traditional one of about 1542, see Penny 2004, 1: 172–81.

22 S. Facchinetti and A. Ng in New York 2019, 134–39, no. 20. P. Humphrey (in Edinburgh 2004, 174) describes the inkstand as bronze, which seems likely.

23 Northern Italian, early 16th century, left foot of the Apollo Belvedere, bronze, h. 8.5 cm, l. 13 cm, Kunsthistorisches Museum, Vienna (I.N. 5631). See Frankfurt am Main 1985, 327, no. 7.

24 The esteem in which it was held is perhaps best expressed by the nineteenth-century German critic Johann Joachim Winckelmann in his *History of Ancient Art*: "The statue of Apollo is the highest ideal of art among all the works of antiquity to have survived destruction" (as translated in Pater 2011, 131–32).

25 See Christian 2008.

26 Montfaucon 1721–22.

27 Montfaucon 1721–22, 5: pt. 1, book 4, 150, pl. 44, no. 9.

28 See *Model of a Right Foot*, Etrusco-Italic, 4th–2nd century BCE, terracotta, Arthur M. Sackler Museum transfer from the Alice Corinne McDaniel Collection, Department of the Classics, Harvard University (2021.1.98).

29 Montfaucon 1721–22, 2: pt. 1, book 4, p. 157.

30 Noted in Hardwick 2020, 66.

31 Bode 1910, xv, xvi, 12, no. 39.

32 Sitwell et al. 1953, 35, 36, no. 18.

33 Goldman 2001, 105–13.

34 Early fundamental studies on Riccio were entries in Bode 1907–12 and Planiscig 1927. The subsequent literature on the sculptor is summarized and synthesized in New York 2008–9.

35 Gauricus 1886, 256–57.

36 New York 2008–9, 158–73, nos. 10, 11, 12.

37 On Ovid and Poliziano, see Wind 1968, 114 and notes.

38 See J. Warren in New York 2008–9, 240–45, no. 23.

39 C. Kryza-Gersch in New York 2008–9, 158.

40 See Motture 2019, 209–15.

41 New York 2008–9, 216–21, no. 19.

42 Radcliffe (1966, 41–43) posits that Riccio was following the advice of his friend Pomponius Gauricus, who in *De Sculptura* advocates that artists draw on literary references for their work, noting one by the Roman poet Statius about an equestrian monument to the emperor Domitian: *Silvae*, book 1, 46–51. See D. Allen in New

York 2008–9, 20–24, for more on the relationship between Riccio and Gauricus.

43 The reliefs on Trajan's Column were widely copied, disseminated by engravings, and influenced many Renaissance artists; Bober and Rubinstein 1986, 191, no. 158c. To cite one example of the reach of these images, copies after drawings of the reliefs by Giulio Romano were followed by Primaticcio, becoming the basis of relief sculpture in France. See Wardropper 1991, 33–34, fig. 8.

44 See New York 1998, 95–96, no. 9.

45 See New York 2008–9, 222–27, no. 20.

46 Of the many examples of this popular subject, a particularly charming one is on a saltcellar in The Frick Collection painted in enamel by Suzanne de Court in the early seventeenth century (1916.4.43). See Wardropper 2015, 68, no. 38.

47 New York 2008–9, 41–42.

48 For a useful summary of the influence of Donatello and Bartolomeo Bellano, among others, on Riccio's formation as a sculptor, see V. Krahn in New York 2008–9, 3–14.

49 For Davide Banzato's discussion of this humanist circle's probable role in the conception of the candelabrum, see New York 2008–9, 40–63.

50 Nagel 2011, 153–94.

51 Banzato (in New York 2008–9, 56–58) reaches this conclusion after reviewing various other interpretations.

52 Among recent interpretations is Nagel 2000, 87–99.

53 Although Radcliffe (1972, 43) was unaware of any classical lamps of this type, Heike Frosien-Leinz (in Frankfurt am Main 1985, 241) identified an ancient lamp in the Musée des Beaux-Arts, Lyon, as did Stéphanie Boucher (1973, 183, no. 326).

54 See, for instance, examples in the Victoria and Albert Museum, the Gutman Collection (Lesley 1968, 104–41, no. 50), and the Louvre (Steingraber 1966, fig. 199).

55 Oman 1963, 3, 11, 15–18, 21, 24; pls. 8–11.

56 Lightbown 1978, 28–34, no. 19.

57 In New York 2008–9 (174–81, no. 13), P. Motture cites previous literature, notably Radcliffe 1972, 29–35.

58 There is a hole in the front center of the poop deck, which, it has been suggested, served to fix a standing figure; P. Motture in New York 2008–9, 177.

59 Edgar Wind (1968, 97–98) credits Aulus Gellius (*Noctes Atticae*, X) with having introduced this motto from the emperor Augustus to the Renaissance. It became a widely popular maxim with various associated devices, including a dolphin around an anchor, a tortoise carrying a sail, and so forth. The Madeira School in McLean, Virginia, still uses this motto.

60 Aristotle 1926, 6: 1142b4–5. See Wind 1968, 100.

61 Wind 1968, 98n.101, 107, 215.

62 S. Boorsch in London and New York 1992, 453–56, no. 148.

63 Wardropper 2011, 50–53, no. 14, with previous literature.

64 Motture 2019, 183, with previous literature.

65 Heike Frosien-Leinz (1985) discusses relationships between the *Hypnerotomachia* and the oil lamps.

66 P. Motture (in New York 2008–9, 180–81) has persuasively drawn connections between the imagery of Cupid, Zephyr, and flames in the poem and Riccio's reliefs on the Cadogan Lamp.

67 Motture 2019, 183. See also Syson and Thornton 2001, 93.

68 Radcliffe (1972, 34–35) and P. Motture (in New York 2008–9, 179) discuss the putto and dolphin motif as a possible allegory of Love Conquers All, citing engraved sources.

69 Elaborate contemporary accounts of royal entries in France in the mid-sixteenth century describe and elucidate such floats. See Saulnier 1955 and McGowan 1970.

70 Radcliffe 1972, 50–55.

71 Radcliffe 1972, 30; P. Motture in New York 2008–9, 174–76.

BIBLIOGRAPHY

Aristotle 1926 Aristotle. *Nichomachean Ethics*. Loeb Classical Library 73, Aristotle XIX. Trans. by H. Rackham. Cambridge, MA, 1926.

Baudelot de Dairval 1686 Baudelot de Dairval, Charles César. *De l'utilité des voyages, et de l'avantage que la recherche des antiquitez procure aux sçavans*. 2 vols. Paris, 1686.

Bober and Rubinstein 1986 Bober, Phyllis Pray, and Ruth Rubinstein. *Renaissance Artists and Antique Sources: A Handbook of Sources*. London, 1986.

Bode 1907–12 Bode, Wilhelm von. *Die italienischen Bronzestatuetten der Renaissance*. 3 vols. Berlin, 1907–12.

Bode 1910 Bode, Wilhelm von. *Bronzes of the Renaissance and Subsequent Periods: The Collection of J. Pierpont Morgan*. Vol. 1. Paris, 1910.

Bode 1980 Bode, Wilhelm von. *The Italian Bronze Statuettes of the Renaissance*. Edited and revised by James David Draper. New York, 1980.

Boucher 1967–71 Boucher, Stéphanie. "Antiquité et Renaissance: Lampes plastiques en bronze des Musées de Lyon." *Bulletin des Musées et Monuments Lyonnais* 4 (1967–71): 245–63.

Boucher 1973 Boucher, Stéphanie. *Bronzes romains figurés du musée des Beaux-Arts de Lyon*. Lyon, 1973.

Christian 2008 Christian, Kathleen Wren. "'Instauratio' and 'Pietas': The della Valle Collections of Ancient Sculpture." In *Collecting Sculpture in Early Modern Europe*, edited by Nicholas Penny and Eike D. Schmidt, 33–36. Washington D.C., 2008.

Colonna 1999 Colonna, Francesco. *Hypnerotomachia Poliphili: The Strife of Love in a Dream*. Trans. and with an introduction by Joscelyn Godwin. New York, 1999.

D'Apuzzo 2017 D'Apuzzo, Mark Gregory. *La collezione dei bronzi del Museo Civico Medievale di Bologna*. Florence, 2017.

Edinburgh 2004 Peter Humfrey. *The Age of Titian: Venetian Renaissance Art in Scottish Collections*. Exh. cat. Edinburgh (National Galleries of Scotland), 2004.

Favaretto 1972 Favaretto, Irene. "Andrea Mantova Benavides: inventario delle antichità di casa Mantovana Benavides, 1695." *Bollettino del Museo Civico di Padova* 61, nos. 1–2 (1972): 35–164.

Favaretto 1980 Favaretto, Irene. "Marco Mantova Benavides tra libri, statue e monete: uno studio cinquecentesco." *Atti dell'Istituto Veneto di Scienze, Lettere ed Arti; Classe di Scienze Morali, Lettere ed Arti* 138 (1980): 81–94.

Favaretto 1990 Favaretto, Irene. *Arte antica e cultura antiquaria nelle collezioni venete al tempo della Serenissima*. Rome, 1990.

Favaretto 2013 Favaretto, Irene. "Marco Mantova Benavides tra sculture, dipinti, libri e naturalia: un collezionista eclettico del Cinquecento." In *Un museo di antichità nella Padova del Cinquecento: la raccolta di Marco Mantova Benavides all'Università di Padova*, edited by Irene Favaretto and Alessandra Menegazzi, 3–16. Rome, 2013.

Frankfurt am Main 1985 Herbert Beck and Dieter Blume, eds. *Natur und Antike in der Renaissance: Ausstellungskatalog.* Exh. cat. Frankfurt am Main (Liebieghaus, Museum alter Plastik), 1985.

Frosien-Leinz 1985 Frosien-Leinz, Heike. "Antikisches Gebrauchsgerät: Weisheit und Magie in den Öllampen Riccios." In Frankfurt am Main 1985, 227–29.

Gauricus 1886 Gauricus, Pomponius. *"De Sculptura" von Pomponius Gauricus* [1504]. Edited by Heinrich Brockhaus. Leipzig, 1886.

Goldman 2001 Goldman, Norma. "Roman Footwear." In *The World of Roman Costume*, edited by Judith Lynn Sebesta and Larissa Bonfante, 101–29. Madison, WI, 2001.

Grandi 1670 Grandi, Iacopo. "Risposta a Girolamo Santasofia . . . intorno a una serpe trovata in un ovo fresco di Gallina." *Giornale de' letterati di Roma.* Rome, 1670.

Gruber 1994 Gruber, Alain, ed. *The History of Decorative Arts: The Renaissance and Mannerism in Europe.* New York, 1994.

Hardwick 2020 Hardwick, Tom. "Stock Trading: Egyptian Collections in the UK." *Apollo* 191, no. 682 (January 2020): 62–67.

Haskell and Penny 1981 Haskell, Francis, and Nicholas Penny. *Taste and the Antique: The Lure of Classical Sculpture, 1500–1900.* New Haven, 1981.

Lesley 1968 Lesley, Parker. *Renaissance Jewels and Jeweled Objects: The Melvin Gutman Collection.* Baltimore, 1968.

Licetus 1652 Licetus, Fortunius. *De lucernis antiquorum reconditis.* Udine, 1652.

Lightbown 1978 Lightbown, Ronald W. *French Silver.* London, 1978.

London and New York 1992 Suzanne Boorsch and Jane Martineau, eds. *Andrea Mantegna.* Exh. cat. London (Royal Academy of Arts) and New York (The Metropolitan Museum of Art), 1992.

McGowan 1970 McGowan, Margaret, ed. *L'Entrée de Henri II à Rouen.* Amsterdam, 1970.

Montfaucon 1719–24 Montfaucon, Bernard de. *L'Antiquité expliquée et représentée en figures.* 15 vols. Paris, 1719–24.

Montfaucon 1721–22 Montfaucon, Bernard de. *Antiquity Explained, and Represented in Sculptures.* Vol. 2. London, 1721–22.

Motture 2019 Motture, Peta. *The Culture of Bronze: Making and Meaning in Italian Renaissance Sculpture*. London, 2019.

Munich 2019 Ulrich Pfisterer and Cristina Ruggero, eds. *Phönix aus der Asche: Bildwerdung der Antike – Druckgrafiken bis 1869*. Exh. cat. Munich (Zentralinstitut für Kunstgeschichte), 2019.

Nagel 2000 Nagel, Alexander. *Michelangelo and the Reform of Art*. Cambridge, 2000.

Nagel 2011 Nagel, Alexander. *The Controversy of Renaissance Art*. Chicago, 2011.

New York 1998 Stuart W. Pyhrr and Jose-A. Godoy, eds. *Heroic Armor of the Italian Renaissance: Filippo Negroli and His Contemporaries*. Exh. cat. New York (The Metropolitan Museum of Art), 1998.

New York 2008–9 Denise Allen and Peta Motture, eds. *Andrea Riccio, Renaissance Master of Bronze*. Exh. cat. New York (The Frick Collection), 2008–9.

New York 2019 Aimee Ng, Simone Facchinetti, and Arturo Galansino, eds. *Moroni: The Riches of Renaissance Portraiture*. Exh. cat. New York (The Frick Collection), 2019.

New York 2019–20 Aimee Ng, Alexander J. Noelle, and Xavier F. Salomon, eds. *Bertoldo di Giovanni: The Renaissance of Sculpture in Medici Florence*. Exh. cat. New York (The Frick Collection), 2019–20.

Oman 1963 Oman, Charles C. *Medieval Silver Nefs*. London, 1963.

Pater 2011 Pater, Walter. *The Renaissance*. Luton, England, 2011.

Penny 2004 Penny, Nicholas, et al., eds. *The Sixteenth-Century Italian Paintings*. London, 2004.

Pesenti 2001 Pesenti, Tiziana. "'Peregrinatio academica' e 'monarchae medicinae': studenti attorno ai Santasofia." In *Studenti, università, città nella storia padvana. Atti del convegno, Padova, 6–8 febbraio 1998*, edited by Francesco Piovan and Luciana Strian Rea, 117–26. Padua, 2001.

Planiscig 1927 Planiscig, Leo. *Andrea Riccio*. Vienna, 1927.

Pope-Hennessy 1970 Pope-Hennessy, John, with Anthony F. Radcliffe. *The Frick Collection, an Illustrated Catalogue*. Vol. 3, *Italian Sculpture*. New York, 1970.

Radcliffe 1966 Radcliffe, Anthony. *European Bronze Statuettes*. London, 1966.

Radcliffe 1972 Radcliffe, Anthony. "Bronze Oil Lamps by Riccio." In *Victoria and Albert Yearbook* 3 (1972): 29–58.

Saulnier 1955 Saulnier, V.-L. "L'Entrée de Henri II à Paris et la révolution poétique de 1550." In *Les Fêtes de la Renaissance*, edited by Jean Jacquot, 31–59. Vol. 1. Paris, 1955.

Sitwell et al. 1953 Sitwell, Osbert, et al. *The Frick Collection: Sculpture of the Renaissance and Later Periods*. Vol. 5. New York, 1953.

Steingraber 1966 Steingraber, Erich. *Der Goldschmied*. Munich, 1966.

Syson and Thornton 2001 Syson, Luke, and Dora Thornton. *Objects of Virtue: Art in Renaissance Italy*. London, 2001.

Thornton 1998a Thornton, Dora. "Instruments and Ornaments for the Study." In Thornton 1998b.

Thornton 1998b Thornton, Dora. *The Scholar in His Study: Ownership and Experience in Renaissance Italy*. New Haven, 1998.

Thornton 2001 Thornton, Dora. "The Status and Display of Small Bronzes in the Italian Renaissance Interior." *Sculpture Journal* 5, no. 1 (2001): 33–41.

Vignon 2019 Vignon, Charlotte. *Duveen Brothers and the Market for Decorative Arts, 1880–1940*. New York, 2019.

Wardropper 1991 Wardropper, Ian. "Le mécénat des Guise: art, religion et politique au milieu du XVIᵉ siècle." *Revue de l'art* 94 (1991): 27–44.

Wardropper 2011 Wardropper, Ian. *European Sculpture, 1400–1900, in the Metropolitan Museum of Art*. New York, 2011.

Wardropper 2015 Wardropper, Ian, with Julia Day. *Limoges Enamels at The Frick Collection*. New York and London, 2015.

Warren 2021 Warren, Jeremy. "The Collecting of Small Bronzes in Late Renaissance Italy: The Canonici Collection." In *Sculpture Collections in Europe and the United States 1500–1930: Variety and Ambiguity*, Studies in the History of Collecting and Art Markets 10, edited by Malcolm Baker and Inge Reist, 46–79. Leiden and Boston, 2021.

Washington, Los Angeles, and Chicago 1986 Manfred Leithe-Jasper, ed. *Renaissance Master Bronzes in the Kunsthistorisches Museum, Vienna*. Exh. cat. Washington (National Gallery of Art), Los Angeles (Los Angeles County Museum of Art), and Chicago (The Art Institute of Chicago), 1986.

Washington and New York 2011–12 Eleonora Luciano and Denise Allen, eds. *Antico: The Golden Age of Bronzes*. Exh. cat. Washington (National Gallery of Art) and New York (The Frick Collection), 2011–12.

Wind 1968 Wind, Edgar. *Pagan Mysteries of the Renaissance*. London, 1968.

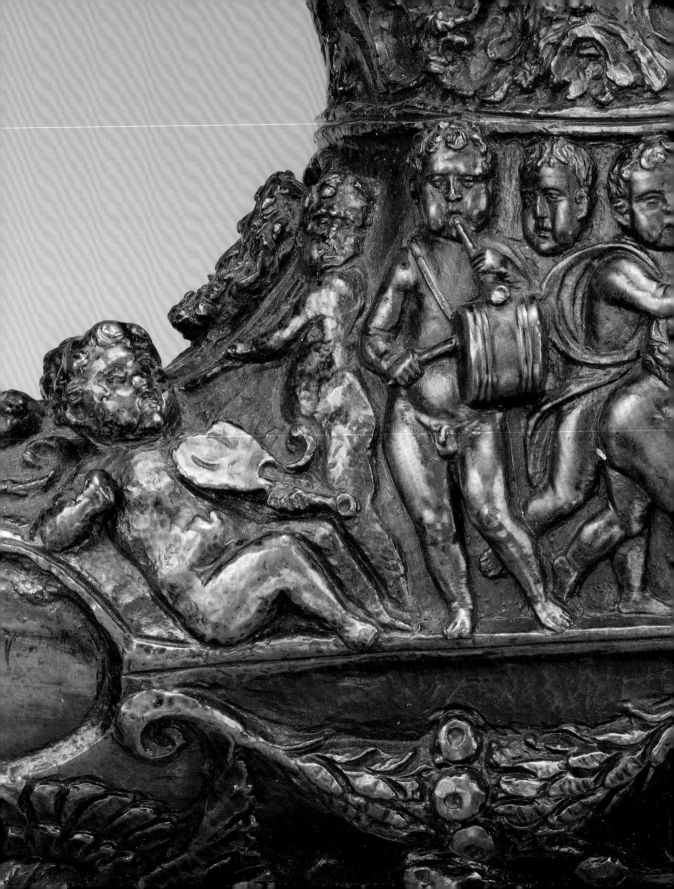

INDEX

Page numbers in *italics* refer to the illustrations.

IMAGE CREDITS